PERE GIMFERRER

MAX ERNST

ACADEMY EDITIONS · LONDON

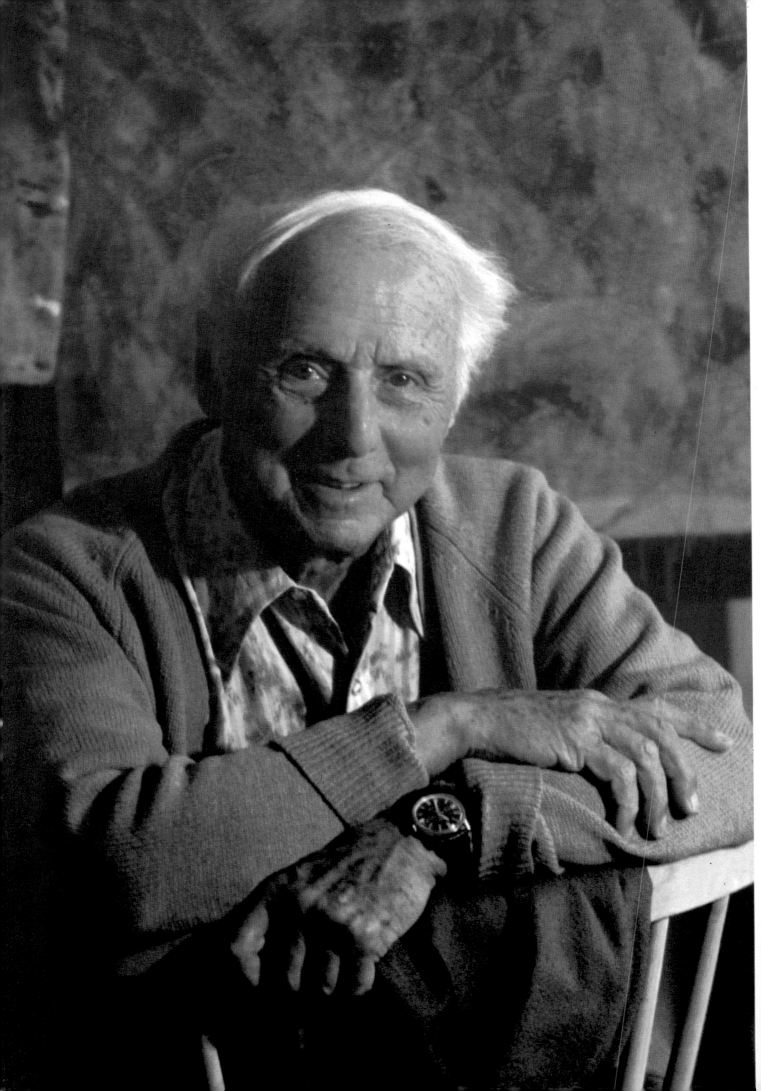

MAX ERNST, OR THE DISSOLUTION OF IDENTITY

'Identity will be convulsive or it will die.' These were the words — a paraphrase of André Breton's famous dictum: 'Beauty will be convulsive or it will die' — which Max Ernst used in 1937 to close one of his most important written works, the one entitled *Beyond Painting*. The early part of this text is a discontinuous series of memorable moments from his own experience, which are swathed in an aureola of Swedenborg's memorabilia as evoked by Gérard de Nerval at the beginning of *Aurelia*, and through which are revealed certain essential clues to Ernst's plastic world as it is related to his inner experiences. For example, there is the vision, in the grain of imitation mahogany, of his father copulating, the figure of his father being associated with the mutation of shapes — whip and top as in *Ubu imperator* (1923) — and with transitions between human and animal; or, again, the hypnological images of the ages of life, with their temporal sequence inverted, in a group of passers-by seen taking a snooze; or the eroticism of a female figure, whose transparency reveals the bones, in a scene of the splitting of personality in which the dreamer sees himself; or the tale, based on a well-known text by Leonardo, of the discovery of *frottage*; and this ultimately derives from the already mentioned appearance of his father in the false mahogany. Then there are the various happenings that he experienced not so much in the role of their 'creator' but more as a witness or as a clairvoyant, which also appealed to Rimbaud. The word 'creator,' incidentally, is one that Ernst attacked with all his enormous capacity for contempt and ridicule.

In the second part of *Beyond Painting*, assuming a tone of false, sarcastic didacticism, closer perhaps to Jarry and the spirit of Dada than to Surrealism, Ernst expounds the conception, mechanics and techniques of collage. In the third part, *Instantaneous Identity*, he proceeds to draw a self-portrait from outside himself, seeing his identity as divided. This splitting of identity was to generate a kind of exchange of energy equivalent to the juxtaposition of dissimilar realities in an unusual situation, like Lautréamont's example of the umbrella and the sewing-machine on a dissecting table. Collage sustains the principle of the union of two dissociated situations in the strictly Dadaist or Surrealist manner; this principle — as distinct from that of *papier collé* and diverging Cubist aesthetics — would seem to stem from Max Ernst, and it is applied, unexpectedly and more radically, to the very nucleus of consciousness,

to the notion of personal identity. Like external reality, we ourselves are dissociated and disintegrated; we are the space at an intersection, a confrontation. The whole of Max Ernst's work takes place in this space — the space of convulsive beauty, which is also the space of convulsive identity.

The fascination of this fact is twofold: the fact itself, and also the acute awareness of it which is demonstrated by Max Ernst. It could be said that this fascination has impinged so strongly on the majority of the artist's contemporaries that very few of them have been capable of reaching beyond the areas of biographical notice or strict descriptivism. During an interview with Max Ernst in 1969, Robert Lebel observed that in fact the painter's own explanations as expounded in *Beyond Painting* had hardly been superseded in most of the extensive bibliography which concerns him. Ernst amended this statement in two ways, on the one hand referring to one of André Breton's principal writings and, on the other, by expressing his confidence that his work was sufficient on its own for those who looked properly. Since that date there have been several critical contributions of major importance, but what always persists is the strange suggestive capacity of this irrepressible personality who, with complete clarity, has not only been present at the work for which he was the vehicle, but has also attended the spectacle of the convulsion of his own identity, the disintegration of his individual consciousness.

Disintegration, or dissolution, is the very essence of *frottage*. This process, which he invented and which is found at the beginning and the end of his career, assumes a special significance in his work. It is in fact a vehicle of irrationality, a means whereby the material itself constitutes the work through the intervention of chance and the accidents of matter in its proper configuration in plastic space. At the point in 1925 when Ernst began his *frottages*, he had emerged with success from the early stages of trials and exploration that mark the beginnings for all artists. He had not only produced several masterpieces, but he moved in an extreme, inquisitive world whose abundance of audacity and germinative power can only be compared to that generated, with a different compass but with profound spiritual affinity, by his friend Joan Miró. During those years, in the lead of a splendid, many-sided generation, they both carved out a unique niche which they have since continued to secure and extend.

Every career has its own particular roots. Initially Ernst started from a rejection of the previous Germanic tradition. The models for his early work belong elsewhere: there is something of Van Gogh in the violent and tortuous colours of certain landscapes; there is the aerial dream-world of Chagall in the arrangement on planes of unreality of everyday figures transposed to the level of magic (as can be seen in works like *Immortality* (1913-14), which heralded the spirit, if not all the techniques, of Surrealism); and Giorgio de Chirico in *Aquis submersus* (1919). But there is one work, which is said to have been commissioned, that showed affinities both with German Expressionism and with Grünewald, and this was to turn up again much later in a painting like

The Temptation of Saint Anthony (1945). Within this early and still relatively undefined framework, a fundamental polarization was introduced by the invention of collage, by his relationship with Arp, and by the spirit of Dada. Following the two portentous works of 1917 with their themes related to the struggles of fish, there arrived the moment of mechanical objects, or of creatures that had the appearance of such objects, and now the unusual derives not from historical precursors, but from the modern world.

At this point we are forced to make a digression, leaving in suspense, floating, a whole area of work to which we can only return and illuminate fully after we have examined the incidence and the ultimate significance of collage. The major works produced by Ernst between 1919 and 1925, whether they are collages or not, have to be seen in relation to this technique. The irruption of *frottage* in 1925 opened a new perspective. Up to that point Ernst's most personal production had isolated concretions and precipitations from a dream-world, or had opposed — with a view either to comparing or identifying them — diverse aspects of reality. But in *frottage* the pencil that one day obeys the rough planks of a wooden floor is now released to respond to the workings of an interior vision, or to face the pictorial volume and the material object, or again to follow a visionary logic in reconstructing the dissociations of sensory perception. However, *frottage* assumes the lines indicated by the material itself, a process of imaginative and visual irritability analogous to that which excited, in the wispy, oily grain of imitation mahogany, the appearance of the figure of his father in a mirror of dim, flickering lights. The liquefied fluid, from the vegetation of rocky edges or from the condensed cloud of a mass of solid vapours, is the very definition of *frottage*, and if the quality of this liquid can drift towards the anthropomorphic plane it will serve to eradicate from the human face every resemblance to its mask, and restore it to that undifferentiated world where man is animal and mineral and vapour and the stalk of a rotting flower.

Metamorphosis: identity dissolves, or perhaps it is just this — unstable, transitory, partaking of the different kingdoms of nature — which is the true identity behind the accustomed mask. We have no face, or perhaps we do not recognize ourselves in our real face — in our absence of face! The world of objects — the human made into an object, the anthropomorphized object, the substitution of static objects in the optical field — is not the only focus of Ernst's attention. What is conceivably the most disturbing facet of his work derives from the potent presence of the natural world, with its systems of ebbing and flowing, of corruption, of communicating vessels. It is the land of nocturnal forests, luxuriant in the silence of sombre metals, as dense as frozen cast iron, or ethereal in the carnivorous curves of vegetation, with bristling feelers and the winking eyes of pests and insects. It is also the land of holy cities, like a desiccated mummy, an altar of stone or metal to the disc of the moon, or the clarities of the sun's alchemy in a stripped and vacant sky. Everything is a temple: the nave for the rites, the night altar, and the chapel of rocks and resin where the birds officiate.

Frottage disappeared from Max Ernst's work during the protracted high point of this period. One might say that the resources of automatism, (not so much 'pure psychic automatism,' but rather, to coin a phrase, a *physical* automatism: matter and technique dictate the work, supporting the visionary ideal by means of a simple transposition that seems mechanical at first sight), had completed their original purpose of introducing doubt concerning visual appearances, whereas collage had earlier, through insidious contrasts, instilled a kind of perpetual uncertainty into the perceptions that we already had. The landscapes, forests and cities of the unforgettable Europe of his prewar works — scenes of burnished gold — now give way to the calcination of wild or desert tracts of America. However, from the end of the fifties one can trace in Ernst an ever growing rejection of certain elements, a process of concentration on forms that are increasingly essential and ever less derived from representations — including internal representations, though it is true that there is hardly any other kind in his work — but closer on the other hand to the pure, chromatic sign of a now indefinite space where the things present are confined with unusual clarity to obvious enigmas or return to the indefiniteness of the original. *Frottage* had appeared during Ernst's youth at a moment of exceptional imaginative vitality but lacking in chromatic content, before the explosion of shapes from an effervescent nature and the dazzle of colour; it reappeared in the sixties when colour had replaced that excess of natural forms. Only the most important ones persist in the diaphanous light of space. Now the eye can see *frottage* anew, with its tactile vision, its geological splendour and its astral mineralogy.

But let us return to the beginning: collage had preceded *frottage*. Moreover, many of Max Ernst's most disturbing works, including some that are widely separated in time, are strictly speaking collages, above all from the moment when *The Hundred-headed Woman* (1929) opened his great series of collage books, recounting novels by means of this technique (if we allow the term 'novel' a broad definition, for we are talking of novels as they might be conceived by a Surrealist spirit). In those works, as U.M. Schneede has pointed out, instead of the juxtaposition of fragments from diverse illustrations on a neutral background, which is typical of the Dada period, there now appears, against an already existing background that acts as a base or support, the introduction of plastic elements derived from other illustrations, and these serve to modify the former. In 1934, for example, for *A Week of Kindness* he started from the illustrations of the newspaper serial *Les damnés de Paris* (1883) by Jules Mary, into which the collage introduces the most cunningly perfidious alterations. For instance, where the illustrator showed a young girl with a low neckline about to embrace a smart-looking soldier with a Napoleonic countenance, Ernst — guided merely by the direction of the woman's gaze and the position of her hands, which allow the subversion of the image from within its own coordinates — introduces beside the officer's face the fascinating mask that serves as the face of a headless man. At his waist, touching and partly enveloping the girl's hand, appears an unidentifiable shape something like a reptile, while the left hand of the headless man fondles

her breast. The whole of the significance of the original drawing has been subjected to a subtle displacement, since the Napoleonic military hero is supplanted in the woman's erotic fantasy — without distorting either the expression or the position of the female figure — by someone from outside. Now we 'know' that the woman is looking somewhere else, to some extent beyond the bounds of the visible space of the original image, or in other words beyond what was permitted by the social decorum of the time. What was a fitting scene within the parameters of a particular society — a young lady of good family, in love or perhaps simply afraid, sheltering in the arms of a dashing officer — is converted into the very opposite. The maiden (for we must suppose that she is such) is now seen to be captivated not by the elegance of this upstanding youth who has obeyed the call to arms, but instead by the apparently depraved attraction of a Plutonic libertine. His missing head, that is, the jeering hole behind the mask, is the final jibe, and, though the intruder is stuck to his side like a Siamese twin, the officer remains unaware that he has been supplanted.

Without falling into a facile and unthinking Freudianism, we should not forget that Ernst read a great deal of Freud in his youth. The snake-like belt of the headless figure replaces the officer's sword. In other words, the phallic symbol that was already present in the original drawing (where the woman's hand is moving towards it) is forcibly replaced by another. In the same way we realize that the frozen stare of the mask has destroyed the attraction which the soldier's eyes previously held for the girl's gaze. To put it another way, Ernst's collage not only destroys the significance of the original work (though without fundamentally altering its arrangement) but also the scale of values on which it is based. In passing, it is worth noting that both the material that is his starting point — that is, the graphic illustrations of minor artists — and also the treatment that he gives it, do not fundamentally differ from things that have appeared much more recently. One thinks of large sections of Pop, whose results only rarely approach the subversive irony and poetic intrigue that we find in Ernst.

There is another revealing case of the conversion of an illustration from *Les damnés de Paris* into a collage in *A Week of Kindness*. This time the figure is an old man, as venerable as Father Time himself, draped in a loose robe or tunic. His dark, deepset eyes look at the spectator with the weary gaze of old age; he raises one hand to his breast in the noble gesture of a figure from tragedy, while the other hand is braced against the wall, thus completing the attitude of someone wishing to express an august, noble sentiment such as affliction, doubt, or perhaps moral resolution. The scene is set in a bourgeois interior that is more or less implied by a drape that we assume leads to a drawing-room.

Just as in the previous case, Ernst does not modify the distribution of the given elements or the position of the main figure, but he directs his experiment towards them in a way basically very similar to that in the amorous scene between the soldier and the girl, though the resources he uses are different. In the first place, the spectator's focal centre in the

picture is the patrician head of the old man and here Ernst works a brutal substitution: he replaces it with another head, that of a lion — the Lion of Belfort according to Ernst himself — which, moreover, insinuates a possible metaphor due to the similarity between the hair of the lion and that of the old man, though the latter's partial baldness contrasts clearly with the luxuriance of the lion's mane. Furthermore — and I believe that in purely plastic terms this change is even more significant than the previous one, attracting still more brusquely the spectator's attention — the figure with the new, anthropomorphized lion's head has stopped looking at us and has turned to look to his right. Ernst thus destroys the convention whereby the gaze leads to an involvement with the spectator within certain shared beliefs established in advance and antedating, as it were, the original illustration. The figure looks to his right and we realize that whatever takes place will happen inside the plastic space, which means that the space is autonomous and is arranged by itself in accordance with internal laws independent of us.

In one of Ernst's major works, *Europe after the Rain* (1940-42), a picture of the inanimate, of the solidification that follows a storm of volcanic lava, it is not by chance that the single element that one might identify as endowed with life — although it, too, has been petrified — is a figure that, as a head, has both the head of a bird and an ancient soldier's metal helmet. This figure, in a gesture whose paralysed immobility will make it difficult to maintain, also looks to his right. Precisely because it is the single animated element, and because of its position, this figure immediately draws our attention, but only so as to reject it; for he is looking once again (though, as we can see, in a different way) 'somewhere else.'

In a way, this new variation on the bird-person — a common element in much of Ernst's work — gives a profound indication of the dividing line between two areas of the picture, despite the fact that it is not strictly in the centre. To the left there is a blue sky, dominated by broken white clouds, that even takes up a large part of the lower zone because of the discontinuity of the reliefs and elevations in the terrain. Beneath this sky reigns the inertia of rocks and monoliths — could they be petrified, mineralized beings? — with their golden and reddish tones. The painting's strict division into two regions arises brusquely with the indefinable mass — rock, person or tree turned into stone, totem, stalagmite — whose greenish hue, together with the funeral pomp of rust, marks the limits of the other area. Here the sky lacks compact cloud formations, and the almost unchanging blue occupies very little space in a vision dominated by an excessive growth of shapes more of the vegetable and animal worlds than of the mineral world, although these are just as much embalmed in the deadly solidification. Among these shapes, which proliferate to the point of invading the upper zone, we can make out a bull's head, some hoofs, an alarming nude whose face is concealed by a vegetable bandage in a mineralized, hostile pavilion, and an entwined complex of roots that are gargoyles and fibrous filaments. Apart from the possibility of an aberrant, larval life latent in such forms, the only true sign of life is found in the helmeted figure whose predatory bird's beak points to the left.

I have intentionally maintained that the bird-man is the only sign of life, although this is not strictly true, because what is seen to the left — that is, the cause of his not looking at us but elsewhere — does not properly belong to the pictorial space. She turns her back on the man with the bird's head — and thus on the spectator, too — and he must find her fascinating because he likewise turns his back on us. This female figure also arises from the petrification; her buttocks are of stone, but they assume the aspect of a burnished shield, and this does not reduce but rather enhances her power of erotic galvanization, and we see her hair, although she is wearing a hat, moving in the wind.

Several questions suggest themselves. Above all: what wind is this? Could a wind exist in this immutable scenario? If there were one, nothing could move: everything, with the exception of her hair, is stone, metal, inert and cruel death. But this wind blows from outside the pictorial space; it is the wind from the 'other place' towards which the female figure is looking. Thus, as well as by her own nature — the transition from the mineral to the living, which escapes the metallic and geological quality that is even noticeable in the creature with the bird's head — by acting the role of a mediating element, it is seen as the vehicle that moves from the zone of the cataclysm towards the region of the blue mountain ridges that incorporate into the stone, modifying its tonality, the serene, impassive colour of the sky, and then beyond the ridges towards somewhere outside the picture, outside the pictorial space.

The hat, the hair, and the radiance of the body with its texture of stone and vegetation relate the eroticism of the figure to that of several other figures that appeared in works of this period, for example *Marlene* (1940-41), and they belong to the theme of woman's mineralization. But the essential point is that the fundamental dynamic of this section of *Europe after the Rain* hardly differs (except at one point, which we shall examine shortly) from that which, after the introduction of the lion's head turned to the left, reigns over the drawing from *Les damnés de Paris* as it is found re-worked in Ernst's collage. In both cases, what is achieved is a total inversion of the conventions of portrait painting, and more specifically of the involvement of the viewer with the person represented. The mineralized woman, the lion-old man, the man with the bird's head, none of these look at us. However, while the last two both look to our left, where we find a female figure (added, in the case of the collage, in front of the drape that presumably leads to a drawing-room), the function of this figure is fundamentally different in the collage and in the painting, and I made an allusion to this difference earlier. The virtuous girl — we must assume that she is virtuous from her hands crossed over her breast in a gesture of modesty or even supplication — does not point outside the plastic space, but rather underlines its cohesive and autonomous quality, its sense of representation (in the theatrical sense) where everything that happens takes place independently of us, in a world apart. In contrast, the woman in *Europe after the Rain* looks *outside:* her space is not that of the picture. This difference is confirmed by another one: *Europe after the Rain* takes place in the open air, the collage from *A Week of Kindness* in an enclosed space.

Nevertheless, the collage undeniably allows the possibility of an external space. I am not referring to the space that obviously exists outside the scene bounded by the illustration (for this continues to belong to the same enclosed space), but rather to something equivalent but unrepresented in the distance, and towards which the woman in *Europe after the Rain* directs her gaze. This something appears in part, hidden in the eyes of the virtuous maiden, enraptured in a devout ecstasy that will soon be filled with nightmares similar to the one that is perhaps passing through her subconscious in this bourgeois interior, and in which other virtuous maidens (or she herself) with eyes closed will, through nightmares, experience other disturbing ecstasies. However, we need not detain ourselves unduly with this possibility, nor with what might await this devout lady if she managed to escape from the space of the illustration — something that would only require one step, since she is already at its edge — or fall into the awesome clutches of the lion-figure if he should decide to spring upon her, or enter who knows what kind of infernal domestic bourgeois interior. Both of these things are improbable, for the attraction of an evil wall seems to lend a strange magnetic effect both to the prudish girl's skirt and to the lion-man's hand, which the wall provides with stimulus and support.

Another element is even more striking: the unexpected shaggy dog, on the right at the feet of the figure in the tunic, that looks upwards almost with suspicion. We do not know what it is looking at, but its gaze (which we see from the front, although it is unaware of our presence) comments sarcastically on the venerable old man of the original serial. In Ernst's reworking, this illustration is transposed — and to that extent heightened — to a disturbing plane, but it has been systematically ridiculed and deprived of significance by the change of context. The operation of collage, thus conceived, shows profound fidelity to the spirit of Dada. There is still someone looking, depicted from the front; but it is not the old man, it is a dog. It is not situated in the upper, central part of the scene, but at an extremity, almost at the lowest possible point. It is not looking at the spectator demanding his involvement, but rather ignoring him for something considerably more attractive. The question as to what this might be must go unanswered. The only thing we know is that, as in *Europe after the Rain,* it is something external to the pictorial space, something that does not attract the attention of the man with the lion's head, absorbed as he is in stalking the maiden. Similarly, the figure with the bird's head looks at the woman, but he does not really see what he is gazing at. Ernst thus sets us in an internal space, a world totally unrelated to normal perception, which is where *A Week of Kindness* and *Europe after the Rain* both take place. This is our mental space and also the space of the picture; that is to say, these are the same dominions that are invaded by *frottage.* At the same time he situates us in a real, external space, outside the pictorial space, outside our mental space, but clearly also outside the space of normal perception.

If we look at the result of the process — at a completed *frottage,* or at a collage, without any knowledge of its original components, or, even more so, at a combination of such techniques or at a painting inspired by

the discoveries of *frottage,* collage, *grattage,* transfers, or dripping — we are still more impressed by the autonomy of the world that is evoked. Obviously, the paths leading to irrationality and the unusual are few and straightforward, as can be noted in the mechanics of the processes just mentioned. In essence, such paths have as a fundamental principle the juxtaposition of two objects in an unwonted situation, after the manner of Lautréamont. Moreover, they usually involve intercommunication or interchange among the different natural kingdoms — the mineral, the vegetable, the animal, and the human — or between natural and mechanical objects; and they introduce within an enclosed frame elements belonging to open space.

Thus, the principle that underlies one of the most important early collages, *Max Ernst's Bedroom; it's worth spending a night here* (1920), is not fundamentally different from that which we observed when we considered the second of the collages from *A Week of Kindness.* In the case of the 1920 collage, the poetic and plastic effects depend on the introduction into a smallish bedroom of living creatures belonging to different areas of the natural world. None of these could ever become acclimatized here, because either they could not stay alive, or they would be harmful, or they would be simply too large, depending on the creature in question: a bear, a large, menacing fish, a small fish, a bat, a snake, a fir-tree growing out of the planks of the floor. Such elements, as well as the alarming transparency of the little cupboard and the almost floating aspect that the furniture acquires from its arrangement in the perspective, define the spatial autonomy evoked by a collage.

However, since we are dealing with a work of art, what is important is not whether the thing is credible in the domain of verifiable experience, but that it provokes an immediate sense of physical impossibility. This feeling is above all the result of the mismatch between the confines of a closed space and these creatures that belong in the open. If our sense of dimension is distorted, the work of art will destroy rationality from its own particular standpoint. The conquests of collage make possible a discovery as subtle as that in the unforgettable *Oedipus Rex* (1921), where the spectator's unease is caused by the impossibility of relying on habitual notions of closed and open spaces. From the proportion of the hand and the nut as compared with the other elements, not even the absence of walls and ceiling or the presence of an aerostatic balloon in the sky can deny us the conviction that we are in an infinitely tiny space and we are choked by the unavoidable claustrophobia of the house that imprisons the hand. And this latter, in its turn, acquires something of an enormous aspect if we compare it with the size of the two little birds' heads emerging from a sort of board, one of which is connected by a thread or string to something outside the picture (another reference to external space). We cannot tell whether it is the hand, the nut or the birds' heads that — gigantic or Lilliputian — does not conform to its natural size, because the whole of the plastic arrangement, based on an unwonted, collage-like system of juxtapositions, is designed to hinder us in this. The perspective extends to a very remote point, almost like Victor Hugo's *plein ciel,* where a Montgolfier balloon serenely floats; but

this background sky, in the sombre colours of ashes and storms, while it is in fact 'external space,' does not reduce the feeling that the scene we are witnessing takes place in the oppressive dimensions of a minuscule receptacle.

Following the same path, we arrive at another of Ernst's masterpieces: *Two Girls Are Threatened by a Nightingale* (1942). Patrick Waldberg has pointed out that if we examine certain elements in this work closely, they turn out to be less remote than we might have expected from the metaphysical painting of de Chirico. Ernst, however, both reaches beyond this framework and incorporates the collage experience in a peculiarly unpleasant and alarming way.

Certain of the work's strictly pictorial components could belong to de Chirico's world: the long wall, the Roman triumphal arch painted in sombre tones as if it were a piece of cardboard or of a jig-saw puzzle; even the two girls, one lying as still as a dummy or a statue, or languishing like a Pre-Raphaelite figure, the other seized by a wind of panic — a purely internal wind, since it affects no other element in the painting, only her — and brandishing, like Judith or the Nike of Samothrace, a carving knife, her arms flung open with the majesty and passion of an ancient tragic heroine. In fact, however, these ingredients, which merely occupy the lower left area of the picture, seem to resemble those in certain of de Chirico's works only if they are isolated and taken out of context, but this similarity is flatly contradicted when they are seen as part of the arrangement that includes them. Above all, the work displays a strong contrast — not unlike the one we observed in *Europe after the Rain* — between the accumulation of elements in the lower section, close to the ground, and the intangible dome of pure blue sky that completely fills the upper zone. Only the strange figure beside the button, caught in a fleeting moment of escape or abduction, seems to intrude into the sky. However, as he is projected forward towards the spectator and thus takes on something of the button's three-dimensionality, he constitutes a frontalized element, the opposite pole and counterbalance to the nightingale which appears at the other side of the picture, infinitely remote from the open gate, elusive up in the blue, but still unexpectedly predatory as it prepares to fall on its victims. The gate, the cabin, the button, all seem to suggest a closed space, but the gate is open and the scene that we are thus allowed to witness takes place, so to speak, in an open space situated within a closed space.

Similarly, in the second of the collages from *A Week of Kindness* that we have already considered, the type of poetic effect that emerges is at bottom analogous to that of *Max Ernst's Bedroom; it's worth spending a night here*, although it is worked differently. In one sense, the scene of the collage from *A Week of Kindness* belongs unequivocally to an interior, enclosed space and can only be conceived there, in the clandestine conspiracy of nineteenth-century bourgeois homes, among walls and drapes, far from the light of day. What is alarming is the presence of the figure with the lion's head. By definition, the animal world (with the exception of a few domesticated creatures) belongs in

the great outdoors, and in particular a lion cannot be imagined save in the open air, on great plains or in dense undergrowth. As with the nightingale in the picture of 1924, the creature in the collage of ten years later seems to have irrupted into the visual field from the distance of a great open space in order to prey on its female victims in a closed space. Again, with the bear, the snake, or the bat of the *Bedroom*, their presence causes unease not because they are menacing, but because of the simple physical discrepancy between their size and movements and the possibilities as a home or shelter inherent in the interior of a human dwelling.

We should, however, go further than this observation, for if the changeable dynamics of the open space-closed space form one of the main weapons in Max Ernst's constant war with habitual perception, the other two, as I mentioned above, are the interchange among the various kingdoms of nature, and also that between natural and mechanical objects. Strictly speaking, this last factor is characteristic of the spirit of Dada, but here it should be understood in a broad yet precise sense, since it is not simply a question of machines but of every kind of artefact, including the work of craftsmen, as these are seen in unusual relationships with the things of nature. This confrontation between the natural and the artificial — manufactured or mechanical — can be effected by means of a collage, as happens with the button or the gate in *Two Girls Are Threatened by a Nightingale*, or through painting alone as in the case of the face, which is an inverted pyramid, of *Euclid* (1945), leaving aside for the moment the other, extremely intricate elements that are involved in this work.

Both the theme of the natural and artificial worlds and that of the intercommunication among the different natural kingdoms bring us to a common obsession: the horror at the loss of identity; that is to say, they bring us to the 'convulsive identity.' The relief, *Fruit of a Long Experience* (1919), startles us with its metaphor of commutation: the electrical elements not only denote, but in fact replace, the sexual organs. In the same way, the *Two Ambiguous Figures* (1919-20) are made up of the pencil, the insect and the robot. More than merely exploring this as a field of enquiry, however, Ernst is concerned to examine the main theme of the convulsion — insecurity, substitution, or loss — of identity that underlies it. By purely plastic means this theme introduces the fascination of the fear of disappearing into, or being absorbed or devoured by, another of nature's kingdoms, or into that one great undifferentiated substratum where all these kingdoms coalesce. Thus, in *A Week of Kindness*, the faceless man supplanted the soldier, and the lion's head replaced the man's.

Our conventional, established image of the world leads us to approve the embrace of the young lady and the soldier and, before the old man, to be inspired with respectful feelings stemming from a common code of values. But from the moment that these conventions are threatened, our identity is liable to vanish at any time, for our security disappears: we no longer know who we are. This theme of the dissolution of identity in

nature, that is to say, the disappearance of the internal, closed space of conscience in the external, open space of the world, has found successive manifestations, each more intensely hallucinatory than the last. First, there is the cycle of works dominated by the apotheosis of vegetation, like *Lust for Life* (1936), where even the animals appear as plants with growing leaves; then the series of dead cities, cold and remotely monumental; and, above all, the series that culminated in the nineteen-forties with the coral, mineral, or mineralized formations that we have seen in *Europe after the Rain*, and which bring together the features of immobility, brilliance and petrification.

We are afraid to be animals, we are afraid to be plants or stones, because we do not know what it is to be human. We are afraid of being something else without knowing what we are or what it means to be another thing. This fear of not being finds expression in various forms: through the fear of being something else, of belonging to another world, through the fear of being animal, mineral or vegetable, or a creature that is none of these. There is, for instance, the complete absence of a face, or its minimal representation without recognizable features, in the blurred, wrinkled space of *frottage*; then we have the face dissolving into a flaky mass (a theme that first appeared in the twenties and that was still to be found in 1974 in *Portrait IX*); and then, in the horrific vision of *The Horde* (1927), in a kind of motif inspired by the Laocoön, the face is identified with the paralysed calm of a colossus that alludes at one and the same time to metal, to rock, to the fossil tree and to the great ape. We are afraid to lose our face, we are afraid to be someone without a face: we are afraid to be not some*one*, but some*thing*.

We have returned by a roundabout route to our starting point: *frottage* began from the loss of identity — the loss of form, the loss of face — through its evaporation into multiple space. Collage investigated the dynamics of the relationship between open space and closed space, between the space internal to the work and the space outside, between the plastic space and the space of perception. This multiplicity of spaces is equivalent to the destruction of space, and it returns us to the dissolution of identity, which Ernst expressed in the twenties through little colour, extreme irrationality and distortion of the image, but in the forties by means of sumptuous colour, a majestic solemnity, and floral and sidereal splendour. These were different ways of expressing the tortured process of dissolution, but they have given way, in the works of old age, to the unexpected serenity of a space at peace, the purity of an immobility that goes beyond the geological and which, in the absence of tension, brings a feeling of being.

We can illustrate this by comparing two series of works that operate on basically similar elements — the popular imagery of an earlier period — and which submit them to an identical process. These two are the series of collages *A Week of Kindness* and, some forty years later, *Common-places* (1971). The most obvious difference is the chromatic colour of *Commonplaces* contrasted with the absence of colour in *A Week of Kindness*, which is confined within the nineteenth-century canons of

book illustration. However, the contrast derives more, and in fact mainly, from the surprising paralysis and calm of the more recent series, quite the opposite of the conflicting extremes and the abundance of argument that we have examined in *A Week of Kindness*. As we have seen, there exists in this earlier series a permanent insecurity, a universe in constant flux, characterized by the unstable, the threatening, and by internal tension. On the other hand, in *Commonplaces* there is a complete or almost complete absence of living beings. If we examine the collage *Where to Unwind the Spool*, we can see the immobility — as in the drawings printed inside cigar boxes — of the houses in a Parisian street, without a trace of human beings, with the ground and pavement invisible, and with no point of reference save a steeple that rises in the distance, at the lower edge of the collage. It is tiny, as if imprisoned between the houses, or as if the street — which we of course cannot see — were a steep hill like some of those in Montmartre.

Once more it might be said that we have returned to the scenes of de Chirico in his metaphysical painting, but Ernst has again gone beyond the area of exploration of de Chirico in that period by introducing elements whose power to disturb finds few equivalents in contemporary art. The window of house number three, which appears in the foreground to the left, is distinguished by at least two unusual features. Consider, on the one hand, the fish-bone on the wall parallel to the bottom of the window. Since it is situated above the door that we cannot see, it could perhaps be the sign of a fishmonger's, but it seems anachronistic to today's viewers and it appears separated from the shop where it would be fitting, and it thus assumes the character of a dreamlike annotation. However, the second feature proves to be even more alarming. Inside the room, which we can see thanks to the open shutters, there appears an indefinable figure with a vague resemblance both to a mattress and to a human being with a featureless face — a new variation of one of Ernst's major themes — who is placed in a distorted, painful posture. He is a soft mass, perhaps dressed in a frock-coat, with his legs twisted in the position of a ballet dancer or an acrobat, and he is squeezed into the tight space between the edge of the lower rail and the upper frame of the window, as if the room that we assume is behind him were too small to contain him. (Once again the dynamics of a creature that is inappropriate for the dimensions of the closed space that it occupies.) In the same way, the windows of the butcher's and the tobacconist's are also exploited to express the unusual. The elements that appear there, filling the whole of the available space, perhaps refer to the merchandise that is sold in such places — pieces of bloody meat or innards in the first case, and a plant perhaps alluding to tobacco in the second — but their character is not unequivocal. They may be pieces of meat, but they are also the abominable foliations of a semi-vegetable being; perhaps it is a plant, but it could also be a formation of cells.

We find the same strange sensation of standstill, of suspense, of the deathly calm of an empty instant in other collages in the series. In the works of his Dadaist period or in *A Week of Kindness* Ernst's black, sarcastic humour was seen in the irruption of something horrific yet

undefined, a theme that still appears, as we have just seen, in the forms to be glimpsed in the windows of *Where to Unwind the Spool*. It is also seen in the creation of monsters, as in the two versions of *The Angel of Hearth and Home* (1937), and leads in the final period of his work to a kind of moral distance that levels and neutralizes, as on a flat surface, one might say unidimensionally, everything that we see. Thus, in another collage from *Commonplaces*, the one entitled *Everyday Life*, those constants reappear that we have seen in the second collage of *A Week of Kindness* and even in *Europe after the Rain*. They are applied here to the condensation of a reduced and absolutely clean, sharp space, without the shadows of *A Week of Kindness*, and without the indefinition of the mineralized masses of *Europe after the Rain*. As in the case of this last painting, *Everyday Life* appears divided into two halves, but here each of the halves completely occupies the visual field. There is no distinction between upper and lower zones, between the sky and the earth; but on the other hand the dividing line is not a volume, like the totem-rock-tree of *Europe after the Rain*, but rather an absence of volume, that is to say, an empty space, so smooth and void that it might pass both for a wall (the delineation of an interior space) and for simply nothing (opening of the interior of a domestic room to the idea of external space).

Like the dog in the collage from *A Week of Kindness*, the cat in *Where to Unwind the Spool* seems to be looking outside the plastic space, and this time one might add: towards the spectator. But at the same time there is another eye, which we can see thanks to a distortion similar to those of many figures by Picasso, but based on a different principle: not decomposition or destruction of the figure in a simultaneous vision, but a rapid superimposition of two images, as in certain tricks of optical illusion. This other eye is looking to the left, like the lion-man, or like the bird-man of *Europe after the Rain*. And on the left there is again a female appearance, though here it is merely a dress without any human form inside. Across the dividing line of the empty space, the cat looks towards the emptiness of the absent woman in the hollow dress. In this dead, make-believe room the cat is looking at nothing.

The work gives us a feeling of impassivity, where the most characteristic elements of Max Ernst's universe are still to be found, but they are at variance with the author's attitude which is now derived from the serenity that follows the acceptance of disappearance. Ernst still offers us the bird, or the undefined being, or the formless, shapeless mass, but now, rather than panic, they seem to express calm in the face of dissolution. The monster still appears, as in *Sign for a School of Monsters* (1968), where a lizard appears on the side of a reddish hill that is typical of Ernst's world; and so does the explosion of a complex and impressive colour scheme, as in the excellent *Explosion in a Cathedral* (1960). But what stands out more and more is the bareness, the clarity, the simple, almost emblematic presence in the dazzle of colour of certain elements that have received their maximum purification, as if after his long immersion in the waters of pre-consciousness that began for him in about 1919, the artist returned, bearing the dark fruits of this voyage, to his original sources. The dazzling precision of *Orbis pictus* (1973) or of

Configurations (1974) or of the miniature universe of the lithographs for the *Ballad of a Soldier* by Georges Ribemont-Dessaignes (based, like *A Week of Kindness,* on the repertory of popular imagery, but this time worked with a conscious simplicity designed to support the poetry, not terror) are some examples showing that Ernst's power to capture the unusual is tending, in the final phases of his life, to replace the horrific fascination of destruction with a serenity found in dissolution.

To proclaim that the world and our identity are illusory and liable to disappear, to proclaim that we do not know what or who we are — the point of departure both of radical criticism, of the profound subversion that Max Ernst displays towards contemporary society, and of his poetic, prophetic lucidity — is to open the floodgates of terror before the mentally unknown and lead, as we saw in the upheaval that was at work in spatial relations, to the physically unknown, to the negation of reality as normally perceived. The liturgy of the Gothic night of forests and stone is therefore necessary; it is both a liberating exorcism and a search for one's identity in a place where no recognizable identities exist. But in the end we see — or think we see — our face: it is not in this place, there is neither face nor place, we have no face because we have no identity. Ernst has reached the space where our face is the disappearance of a face, where our identity is the dissolution of identity.

CHRONOLOGY

1891 Birth of Max Ernst, at Brühl, near Cologne, in the Rhineland, on April 2; he is the second child in a Catholic family with five daughters and two sons. His father is a teacher at a school for deaf mutes.

1909 Finishes school and enters the Arts Faculty of Bonn University, where he enrols in the philosophy department.

Takes up psychiatry and visits a mental home outside Bonn, where he is fascinated by the paintings and sculptures of the inmates.

1912 Visits the *Sonderbund* exhibition in Cologne, which includes works by Cézanne, Van Gogh, Gauguin, Munch, Picasso, Matisse, etc.

Decides to become a painter.

1913 Exhibits, along with Arp, Klee, Chagall and Delaunay, in the *Erster Deutscher Herbstsalon* (1st Autumn Salon), presented in Berlin by the review *Der Sturm*.

Meets Apollinaire through Macke, who is a friend of Ernst.

First journey to Paris.

1914 Makes the acquaintance of Hans Arp in Cologne, the beginning of a lifelong friendship.

1914-1918 Serves in an artillery regiment throughout the war.

1916 In January the review *Der Sturm* organizes an exhibition of his works in Berlin; on this occasion he meets Georg Grosz.

1917 Participates in the second Dada exhibition in Zürich.

1918 Granted 'matrimonial leave,' he marries Louise Strauss, art historian and assistant to the Curator of the Wallraf-Richartz Museum in Cologne.

After his demobilization, Max Ernst settles in Cologne.

Establishes contact with subversive circles in Munich, Berlin and Zürich.

1919 Makes the acquaintance of J. T. Baargeld and with him founds the Dada movement in Cologne. Hans Arp joins them and between the three they found *Zentrale W/3 Stupidia*.

Discovers reproductions of works by Giorgio de Chirico in the review *Valori Plastici*.

In the same year he publishes an album of eight lithographs entitled *Fiat modes, pereat ars*, in homage to Chirico.

First collages and experiments based on printed 'images.'

1920 Collaborates with Arp and Baargeld on a series of collages they call *Fatagaga*, which is intended to stand for FAbrication de TAbleaux GArantis GAzométriques ("MAnufacture of PIctures GUaranted GAzometric"). Second and final Dada exhibition in Cologne, at the Winter Beer-house. Birth of his son Ulrich (Jimmy), today also a painter.

1921 Corresponds with André Breton, who invites him to show his collages in Paris. Exhibition entitled *La mise sous whisky marin* at the Au Sans Pareil bookshop; Dada manifestation at the opening.

Gala and Paul Éluard visit Cologne. Ernst forms a lifelong friendship with Paul Éluard.

1922 Not having obtained a visa, he enters France illegally, and stays with Éluard, with whom he publishes *Les malheurs des immortels*. Does collages for *Répétitions*, an anthology of poems by Paul Éluard.

Meets Francis Picabia and Man Ray.

1923 Exhibits in Paris, at the *Salon des Indépendants*. Decorates Paul Éluard's house at Eaubonne with murals.

Earns his living by working in a fancy-goods factory that produces cigarette-cases and trumpery bracelets.

1924 Leaves France with Gala Éluard to go and find Paul Éluard, who has gone away alone in search of adventure and ended up in Saigon.

On his return he discovers, with delight, André Breton's *First Surrealist Manifesto*.

1925 Contract with Jacques Viot, 'private agent,' who also signs contracts with Arp and Miró.

Becomes interested in the technique of *frottage* and begins the series entitled *Histoire naturelle* (Natural History).

Takes part in the first exhibition by the Surrealist group.

1926 With Joan Miró, does the décor and customs for Diaghilev's ballet *Romeo and Juliet*. Publication of the *Histoire naturelle*.

1927 Further develops the *frottage* technique and experiments with it in painting: 'grattage.' Marries Marie-Berthe Aurenche.

1929 Publication of the 'collage-romance' *The Hundred-headed Woman*.

1930 Takes part in the shooting of the film *L'âge d'or*, by Luis Buñuel and Salvador Dalí, in which he plays a small part as a beggar.

1933 His name is entered in the list of those proscribed by the Nazi regime.

1934 Meets James Joyce in Zürich.

Participates, with Miró, Arp, Giacometti and Julio González, in the exhibition at the Kunsthaus in Zürich entitled *What is Surrealism?* Max Ernst writes the preface to the catalogue.

1936 Meets Leonor Fini.

Is separated from Marie-Berthe Aurenche.

Develops the transfer process — a technique introduced by the painter Oscar Domínguez — and applies it to oil painting.

1937 Meets Leonora Carrington.

Some of his works are included in the Nazi exhibition *Entartete Kunst* (Degenerate Art) in Munich.

1938 To show his solidarity with Paul Éluard, who has been excluded from the Surrealist group, Max Ernst leaves the group.

He moves to Saint-Martin-d'Ardèche with Leonora Carrington.

1939 Being a German national, is interned: thanks to Paul Éluard's appeal to Albert Sarraut, is liberated.

1940 Interned again, escapes twice. On his return, learns that Leonora Carrington, ill and disturbed, has fled to Spain, where she has been interned in a mental home.

1941 Meets André Breton in Marseilles; an attempt at reconciliation. Is wanted by the Gestapo. Meets Peggy Guggenheim, who helps him. Leaves France for Lisbon, on his way to New York. Marriage to Peggy Guggenheim. Participates with André Breton in the activities of the Surrealist artists in exile.

1942 Experiments with the new technique of 'dripping,' which he uses most notably in *Jeune homme intrigué par le vol d'une mouche non-euclidienne* (Young man intrigued by the flight of a non-Euclidean fly).

Joins André Breton on the editorial board of the review *VVV*; meets the painter Dorothea Tanning.

1946 Marries Dorothea Tanning in California. Settles in Sedona (Arizona).

1948 Max Ernst becomes an American citizen.

1949 Marcel Duchamp visits him at Sedona. Travels in Europe.

1950 Exhibits in Paris and London and is reunited with Éluard, Arp, Giacometti, Tzara and other old friends.

1952 Yves Tanguy visits him at Sedona.

Lectures at the University of Hawaii.

1953 Returns to Europe with Dorothea Tanning. Settles in Paris.

1954 Grand Prix for painting at the twenty-seventh Venice Biennale, at which Hans Arp receives the Grand Prix for sculpture and Joan Miró the Grand Prix for graphic arts.

1958 Becomes a French citizen.

1959 Retrospective at the Musée d'Art Moderne, Paris.

1964 With Dorothea Tanning, moves into a house at Seillans, in the South of France.

1970 Publication of *Écritures*, which contains all his writings.

1975 Important retrospective at the Galeries Nationales du Grand Palais de Paris.

1976 2 April: death of Max Ernst in Paris.

ILLUSTRATIONS

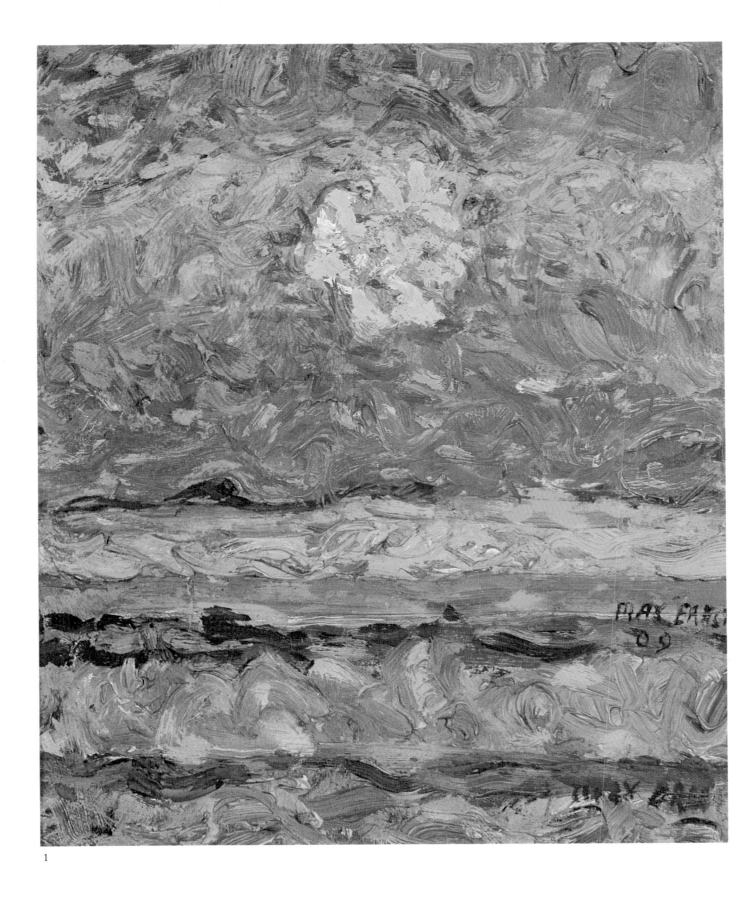

1

1. *Landscape with Sun.* 1909.
 Oil on cardboard, 16.5 × 14 cm.
 The artist's collection.

2. *Self-portrait.* 1909.
 Oil on cardboard, 18 × 12 cm.
 Stadt Brühl collection.

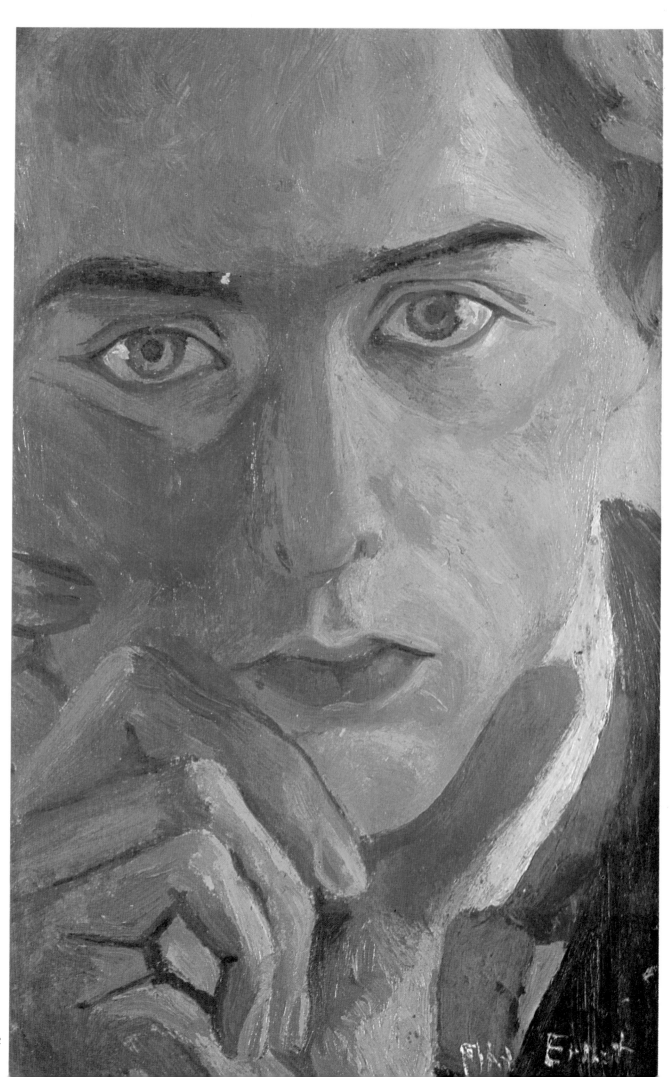

3

4

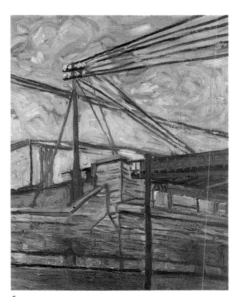

5

6

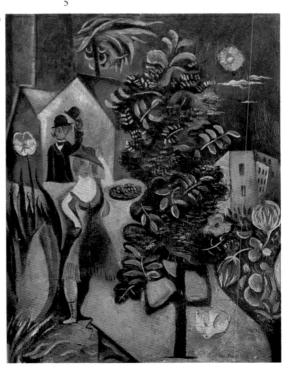

3. *Landscape with Sun.* 1909.
 Oil on cardboard, 18 × 13.5 cm.
 The artist's collection.

4. *Street in Paris.* 1912.
 Watercolour on paper, 34 × 44.2 cm.
 Kunstmuseum collection, Bonn.

5. *The Railway Viaduct over the Commesstrasse,
 Brühl.* 1912.
 Oil on cardboard, 46 × 36 cm.
 Stadt Brühl collection.

6. *Hat in Hand, Hat on Head. c.* 1913.
 Oil on cardboard, 36.8 × 29.2 cm.
 Roland Penrose collection, London.

7. *Immortality.* 1913-1914.
 Oil on wood, 46 × 31 cm.
 Minami Gallery, Tokyo.

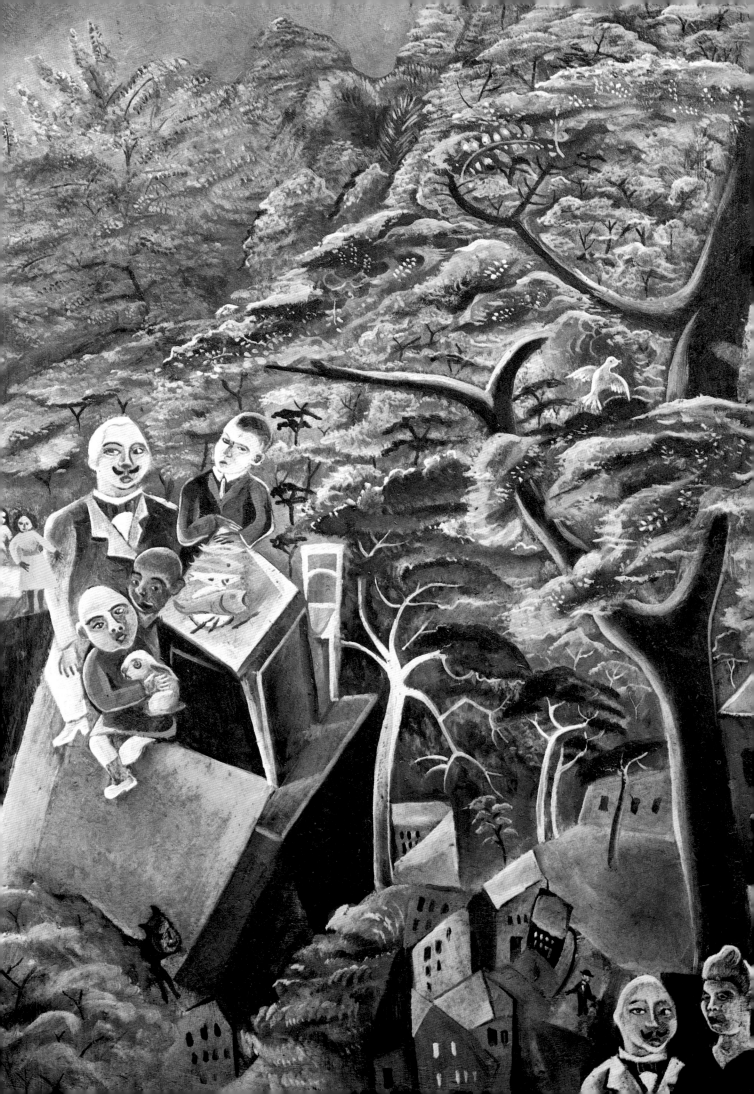

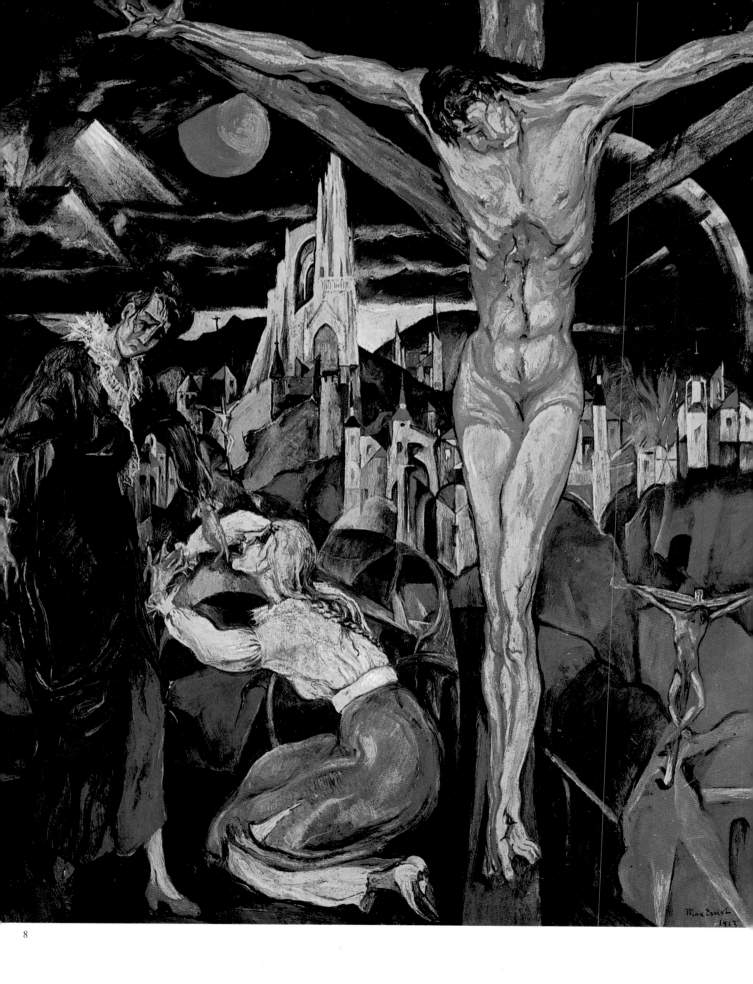

8

8. *Crucifixion.* 1913.
Oil on paper, 51 × 43 cm.
Wallraf–Richartz Museum, Cologne.

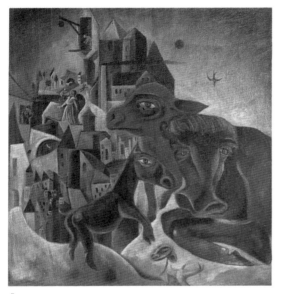

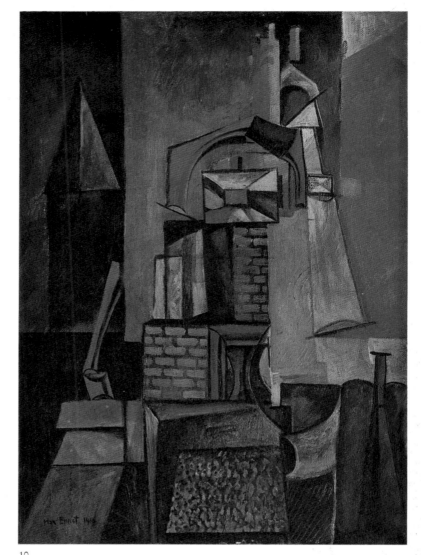

9 10

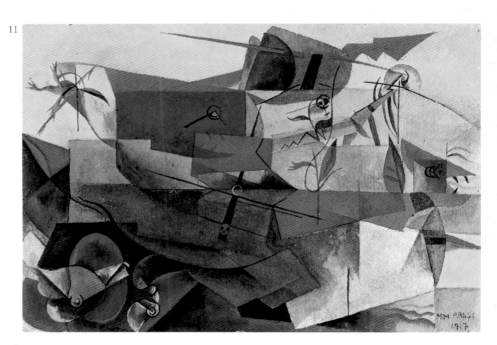

11

9. *Town with Animals or Landscape.* c. 1916.
 Oil on canvas, 66.6 × 62.2 cm.
 The Solomon R. Guggenheim Museum, New York.

10. *Menace-Machines (Towers).* 1917.
 Watercolour on paper, 14.6 × 22 cm.
 Private collection, Paris.

11. *Landscape.* 1917.
 Watercolour on paper, 15 × 22 cm.
 M. H. Franke collection, Murrhardt.

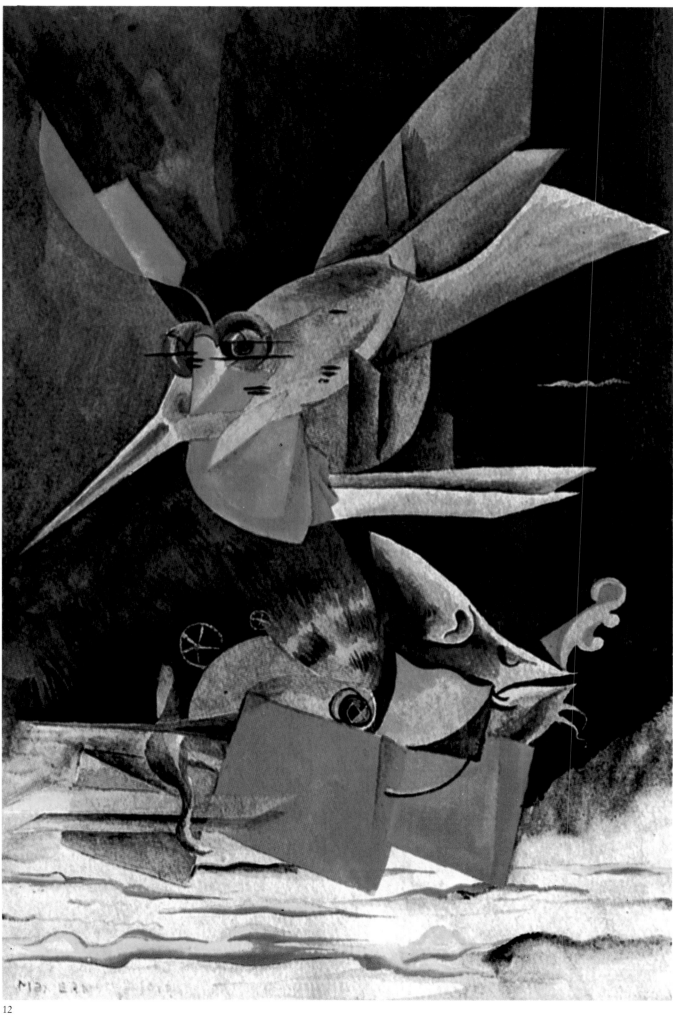

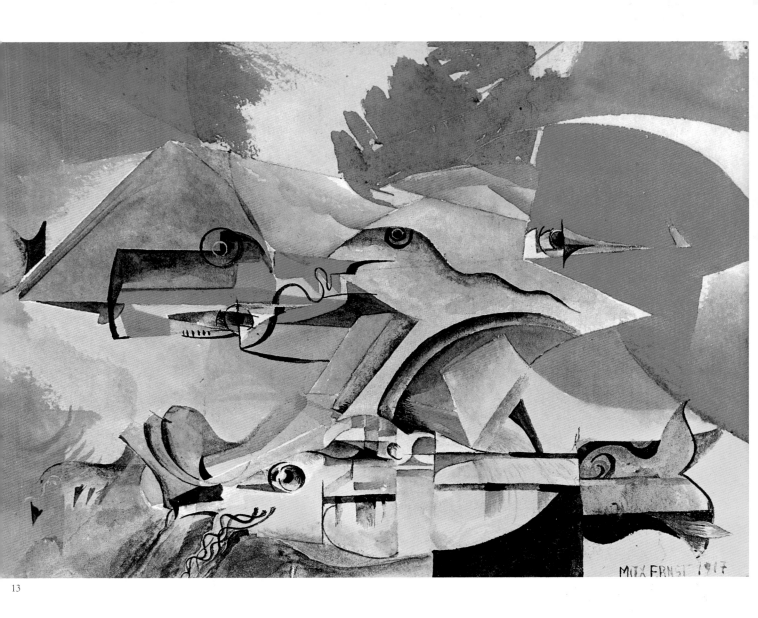

13

12. *Battle of Fish.* 1917.
 Watercolour on paper, 21.7 × 14.5 cm.
 M. H. Franke collection, Murrhardt.

13. *Battle of Fish.* 1917.
 Watercolour on paper, 14 × 20.5 cm.
 The artist's collection.

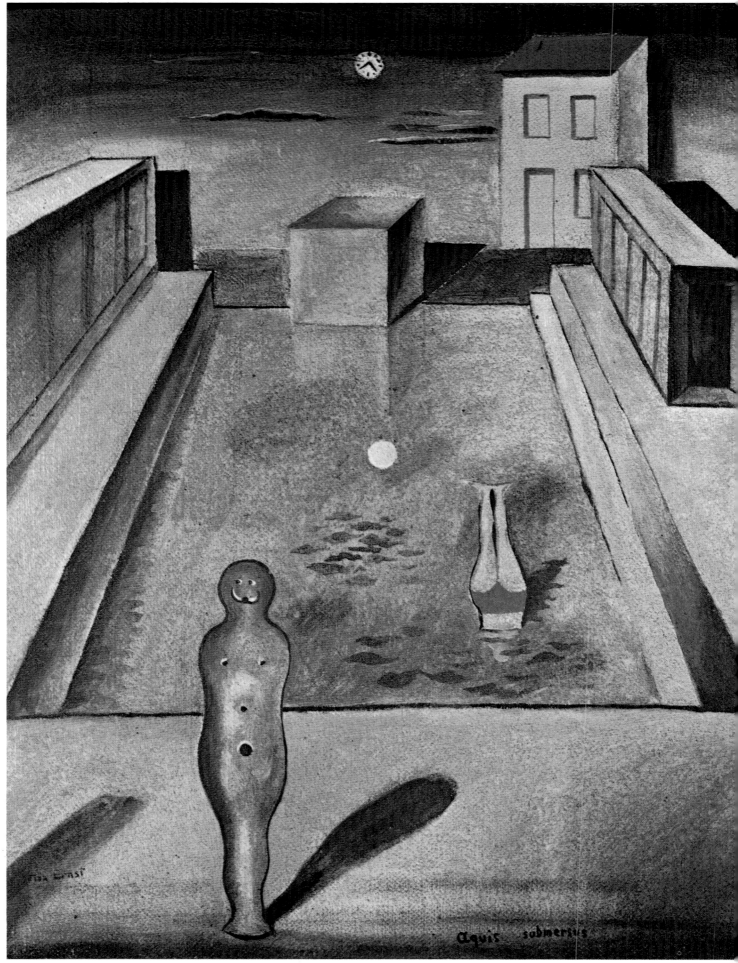

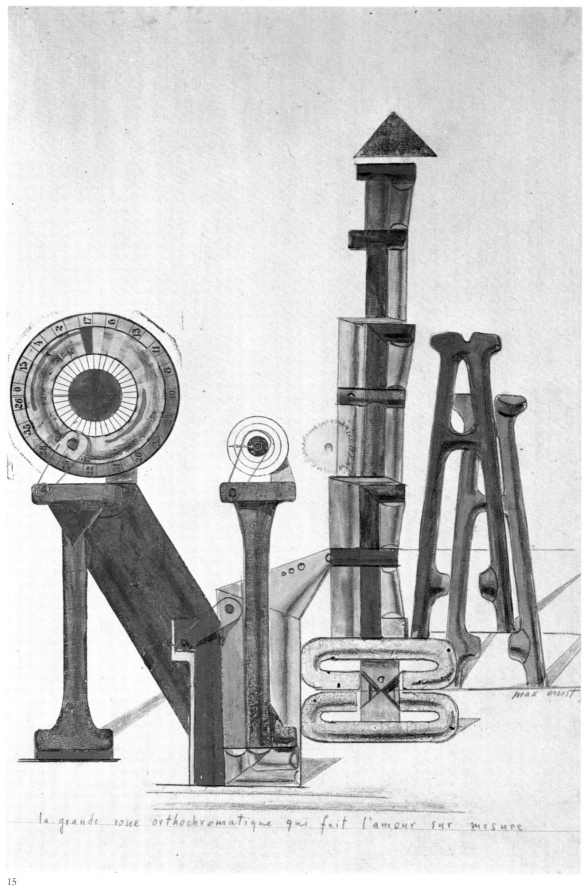

la grande roue orthochromatique qui fait l'amour sur mesure

15

14. *Aquis Submersus.* 1919.
 Oil on canvas, 54 × 43.8 cm.
 Roland Penrose collection, London.

15. *The great orthochromatic wheel that makes love to measure.* 1919-1920.
 Watercolour and pencil on printed sheets, 35.5 × 22.5 cm.
 Michel Leiris collection, Paris.

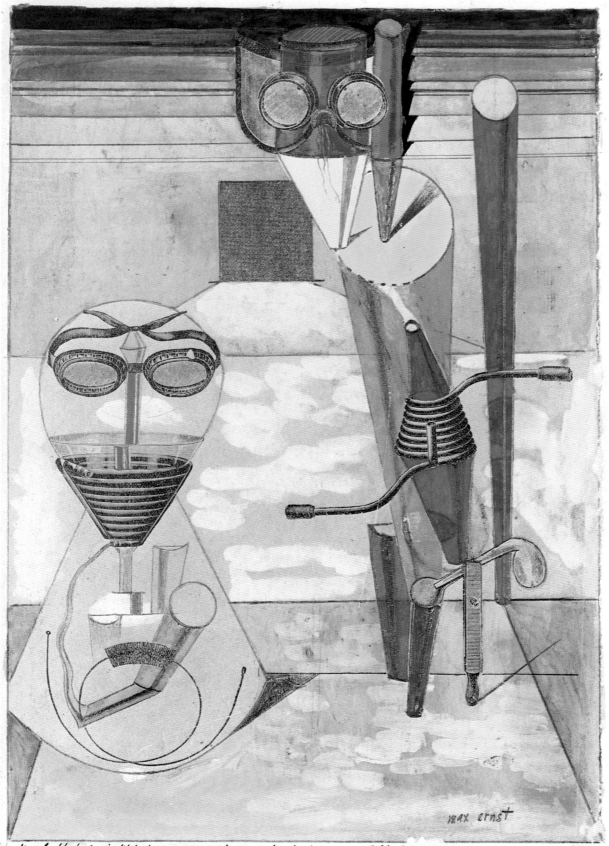

1 Kupferblech 1 zinkblech 1 gummituch 2 tastzirkel 1 abflußfernrohr 1 röhrender mensch

16

16. *Two Ambiguous Figures.* 1919-1920.
 Collage with gouache and pencil on paper, 24.2 × 16.7 cm.
 Arp collection, Clamart (missing since 1966).

17. *Fruit of a Long Experience.* 1919.
 Relief, painted wood and metal, 45.7 × 38 cm.
 Private collection, Geneva.

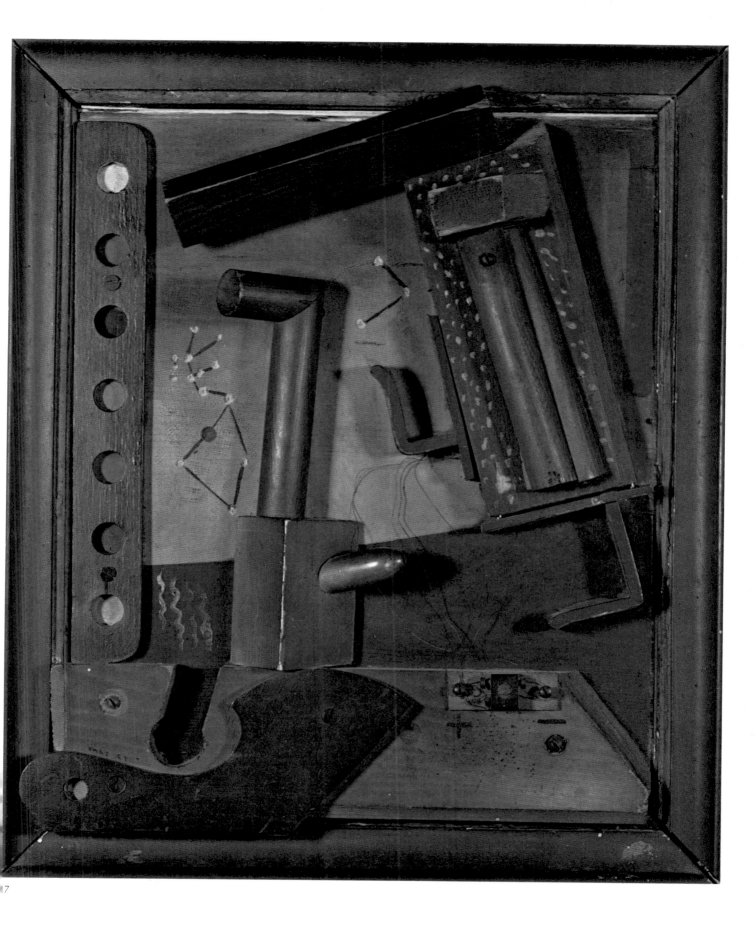

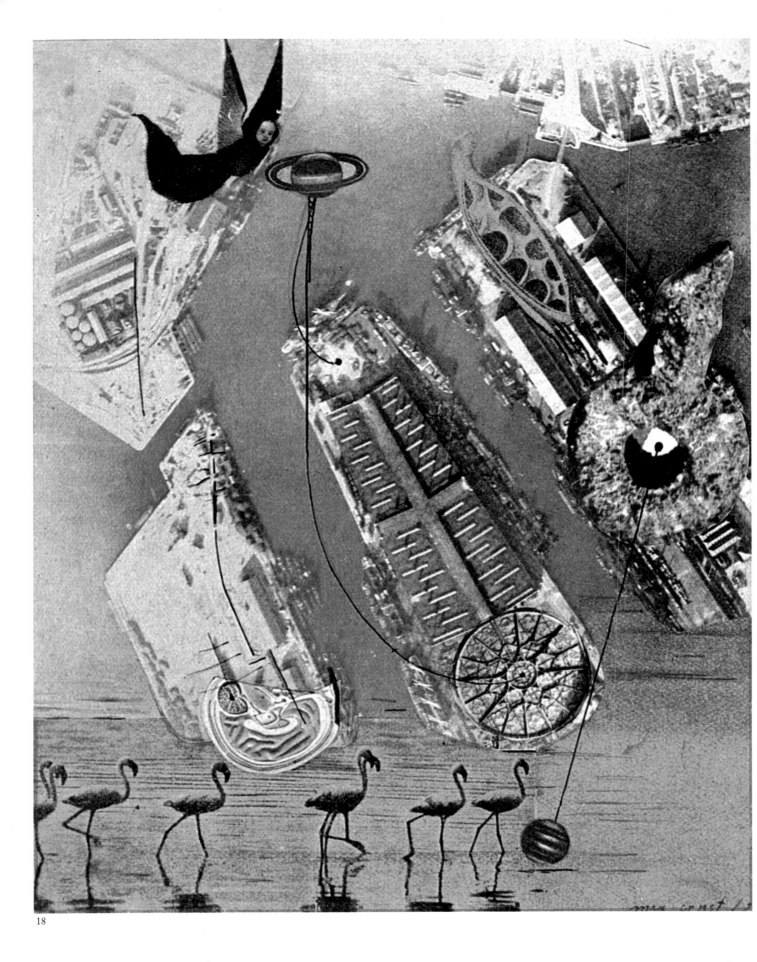

18

18. *The Cormorants*. 1920.
Photocollage and Indian ink on paper (Fatagaga), 15.5 × 13 cm.
Simone Breton-Collinet collection, Paris.

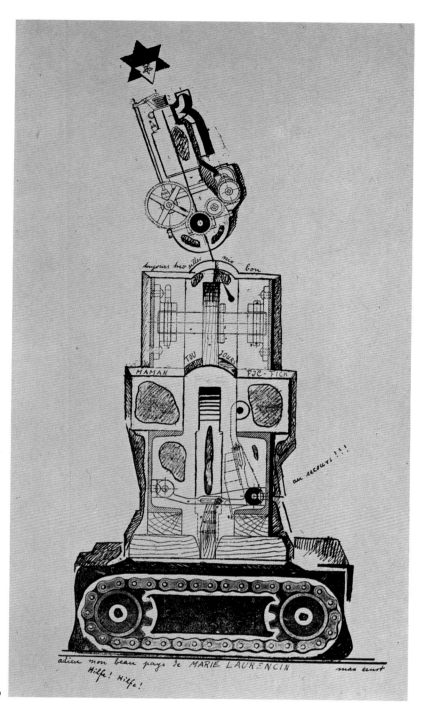

19

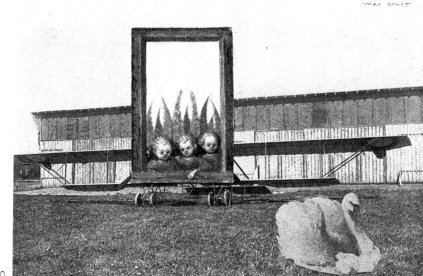

19. *Farewell my Fair Land of MARIE LAURENCIN*. 1919.
Printer's proof and ink on paper, 39.3 × 27.5 cm.
The Museum of Modern Art, New York.

20. *The Swan is Very Peaceful*. 1920.
Photocollage, 8.3 × 12 cm.
Mrs Alfred H. Barr Jr collection, New York.

20

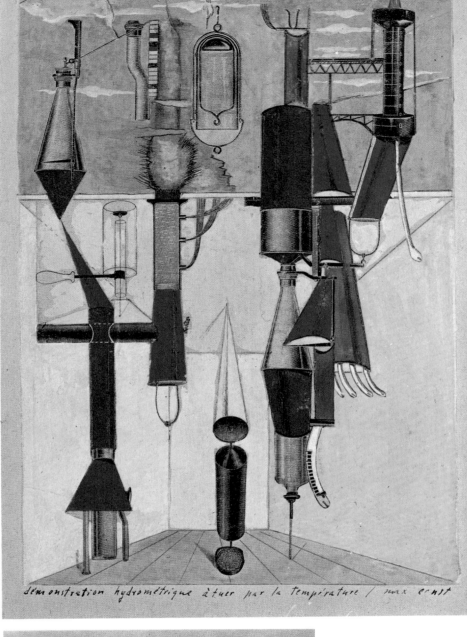

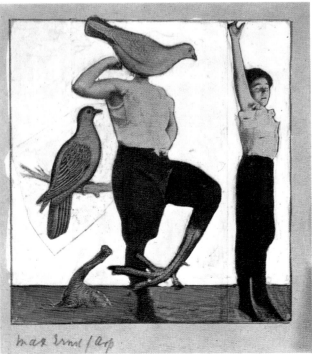

21. *Hydrometric demonstration of how to kill by temperature.* 1920.
Collage and gouache on paper, 24 × 17 cm.
J. Tronche collection, Paris.

22. *Switzerland, Birth-Place of Dada*
or *Physiomythological Flood-Picture.* 1920.
Fatagaga done in co-operation with Hans Arp.
Collage on paper, 11.2 × 10 cm.
Kestner-Museum, Hanover, Fritz-Behrens collection.

23. *Augustine Thomas and Otto Flake* or *Otto Flake synthesizes the art
of the corset with the taste for fine stuffs and metaphysical meat,
while Arp prefers the meat of the flowers of evil.* 1920.
Photocollage by Louise Ernst-Strauss on paper, 23 × 13.5 cm.
Kestner-Museum, Hanover, Fritz-Behrens collection.

24. *Mine Hostess on the Lahn.*
Collage with gouache and watercolour on paper, 25 × 31.5 cm.
Private collection, Stuttgart; on permanent loan to Staatsgalerie, Stuttgart.

25. *Above the clouds goes the midnight. Above the midnight glides
the invisible bird of the day, a little higher than the bird
the ether blows, and the walls and the roofs float.* 1920.
Photocollage and pencil, 18.3 × 13 cm.
Mrs. Alfred H. Barr Jr collection, New York.

26. *The Chinese Nightingale.* 1920.
Photocollage and Indian ink on paper, 12.2 × 8.8 cm.
Guy Genon-Catalot collection, Paris.

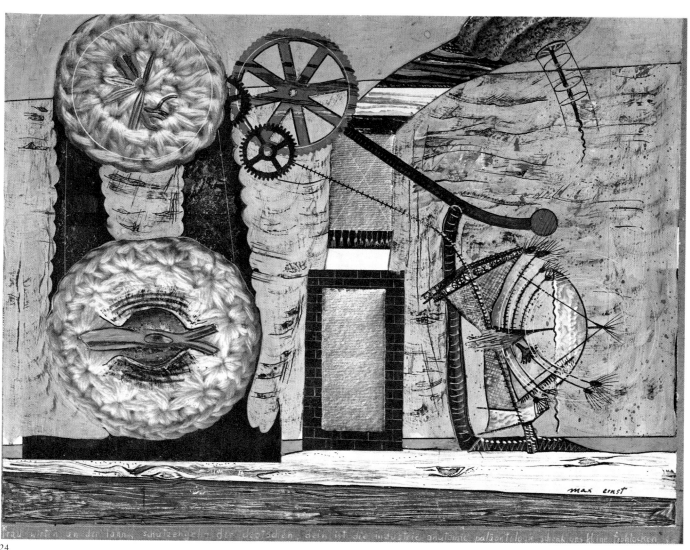

24

25

26

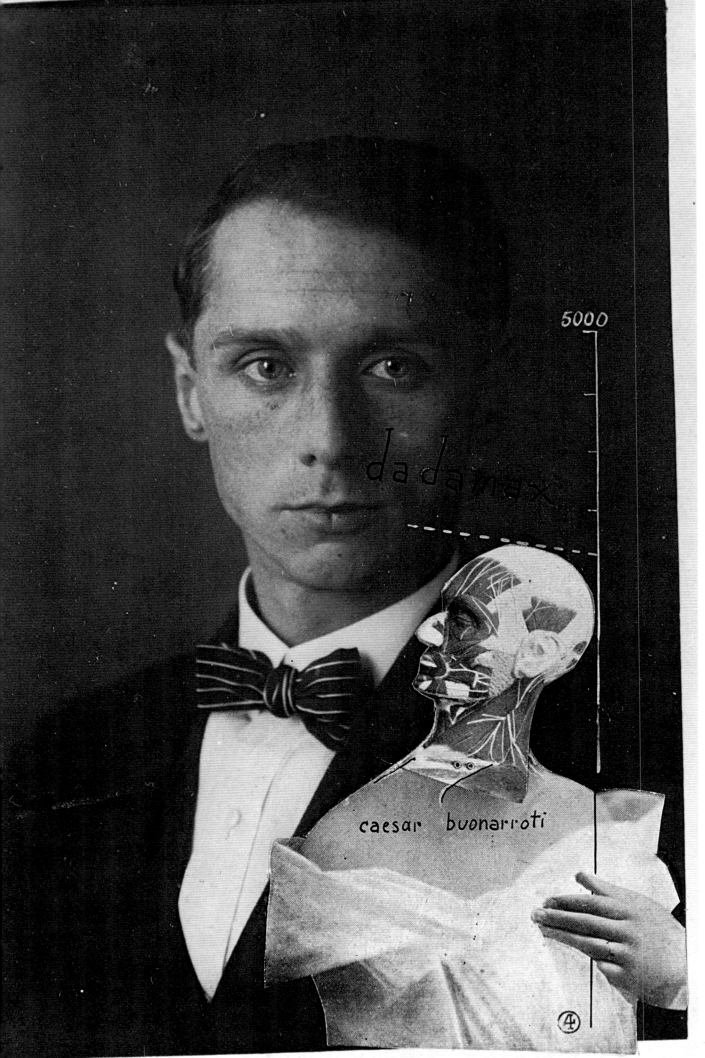

dadamax

caesar buonarroti

5000

27

la petite fistule lacrimale qui dit tic tac /max ernst

28

29

27. *The Punching-Ball* or *The Immortality of Buonarotti* or *Max Ernst
 and Caesar Buonarotti.* 1920.
 (Fatagaga). Collage, photograph and gouache on paper, 17.6 × 11.5 cm.
 Arnold H. Crane collection, Chicago.

28. *The Little Tear Gland that Says Tick-Tock.* 1920.
 Gouache on wallpaper, 35.6 × 25.4 cm.
 The Museum of Modern Art, New York.

29. *Dada-Degas.* c. 1920.
 Collage and gouache on paper, 48 × 31 cm.
 Louis Aragon collection, Paris.

30. *Manifesto: Dada Stirs Everything Up.*
 Paris, 12 January 1921.
 B. Gheerbrant collection, Paris.

30

(Les Signataires de ce manifeste habitent la France, l'Amérique, l'Espagne,
l'Allemagne, l'Italie, la Suisse, la Belgique, etc., mais n'ont aucune nationalité).

DADA SOULÈVE TOUT

DADA connaît tout. DADA crache tout.

MAIS.......

DADA VOUS A-T-IL JAMAIS PARLÉ :

OUI = NON

OUI = NON

OUI = NON

de l'Italie
des accordéons
des pantalons de femmes
de la patrie
des sardines
de Fiume
de l'Art (vous exagérez cher ami)
de la douceur
de d'Annunzio
quelle horreur
de l'héroïsme
des moustaches
de la luxure
de coucher avec Verlaine
de l'idéal (il est gentil)
du Massachussetts
du passé
des odeurs
des salades
du génie . du génie . du génie
de la journée de 8 heures
et des violettes de Parme

JAMAIS JAMAIS JAMAIS

DADA ne parle pas. DADA n'a pas d'idée fixe. DADA n'attrape pas les mouches

LE MINISTÈRE EST RENVERSÉ. PAR QUI? PAR DADA

Le futuriste est mort. De quoi ? De DADA
 Une jeune fille se suicide. A cause de quoi ? De DADA
 On téléphone aux esprits. Qui est-ce l'inventeur ? DADA
 On vous marche sur les pieds. C'est DADA
OUI = NON
 Si vous avez des idées sérieuses sur la vie,
 Si vous faites des découvertes artistiques
 et si tout d'un coup votre tête se met à crépiter de rire,
 si vous trouvez toutes vos idées inutiles et ridicules, sachez que

C'EST DADA QUI COMMENCE A VOUS PARLER

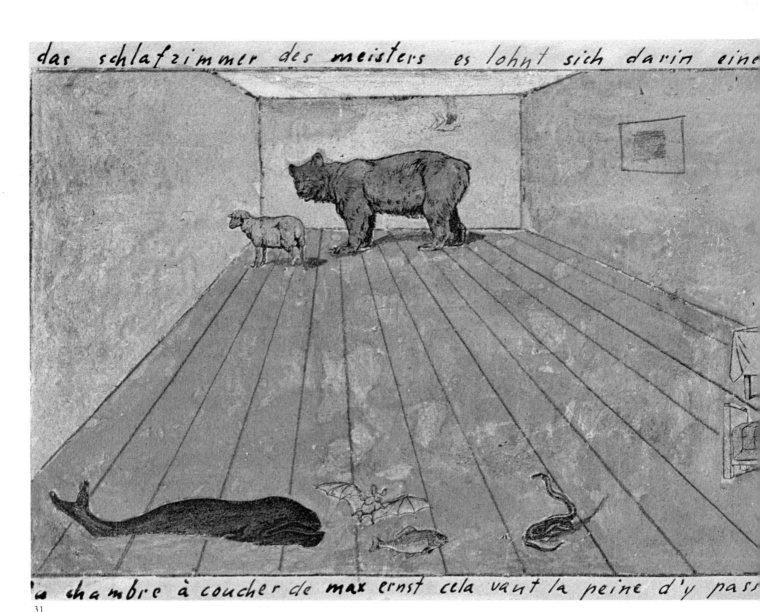

das schlafzimmer des meisters es lohnt sich darin eine

la chambre à coucher de max ernst cela vaut la peine d'y pass

31

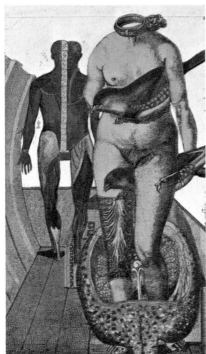

32

31. *Max Ernst's Bedroom; it's worth spending a night here. c.* 1920.
Collage with gouache and pencil on paper, 16.3 × 22 cm.
Werner Schindler collection, Zürich.

32. *The Word* or *Bird-Woman.* 1921.
Illustration for *Répétitions* by Paul Éluard, 1922.
Collage and gouache on paper, 18.5 × 10.6 cm.
E. W. Kornfeld collection, Berne.

33. *Glacial Landscapes, Icicles & Minerals of the Female Body.* 1920.
Collage, gouache and watercolour on paper, 25.3 × 24.4 cm.
Moderna Museet, Stockholm.

34. *The Horse, He's Sick.* 1920.
Collage, pencil and ink on paper, 14.5 × 21.6 cm.
The Museum of Modern Art, New York, Abby Aldrich Rockefeller Fund.

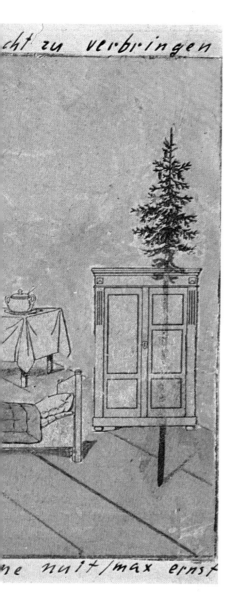

cht zu verbringen

ne nuit / max ernst

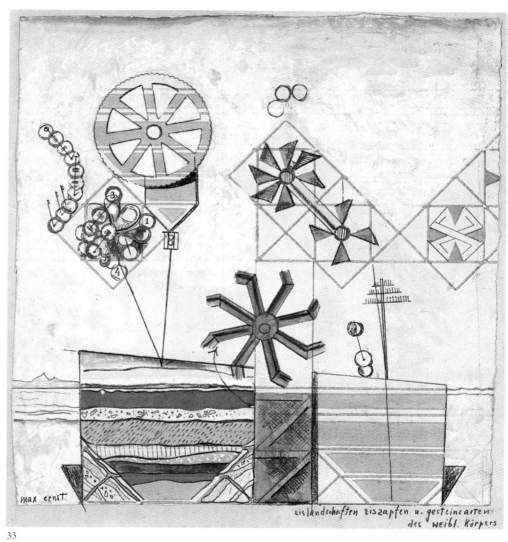

max ernst

eislandschaften eiszapfen u. gesteinsarten
des weibl. Körpers

33

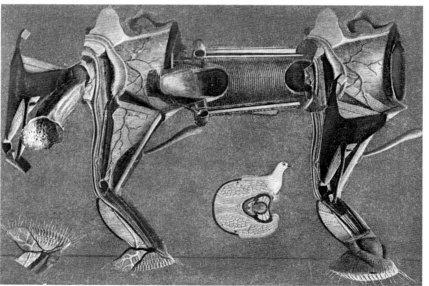

34

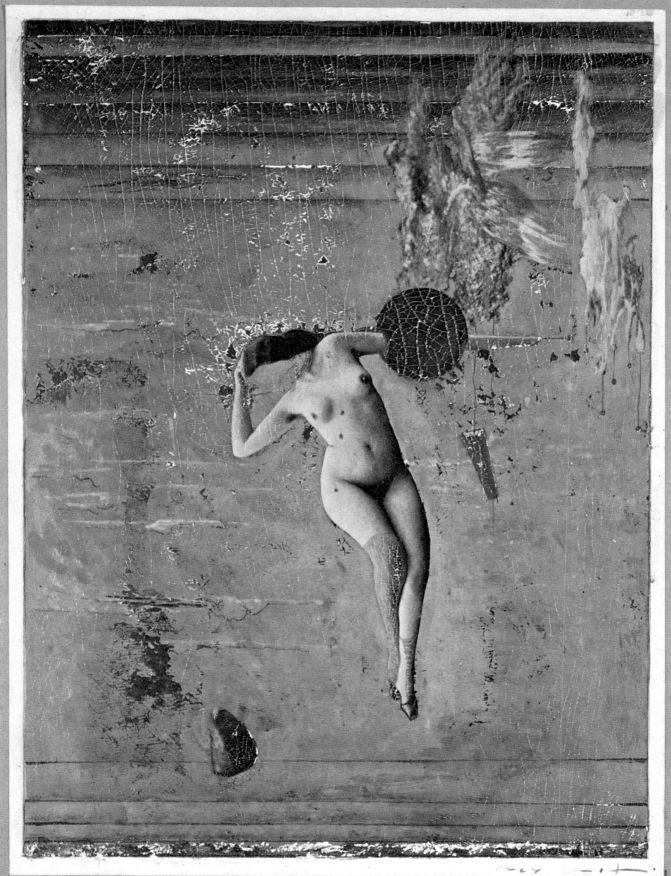

La puberté proche n'a pas encore enlevé la grâce tenue de nos pléiades / Le regard de nos yeux pleins d'ombre est dirigé vers le pavé qui va tomber / La gravitation des ondulations n'existe pas encore

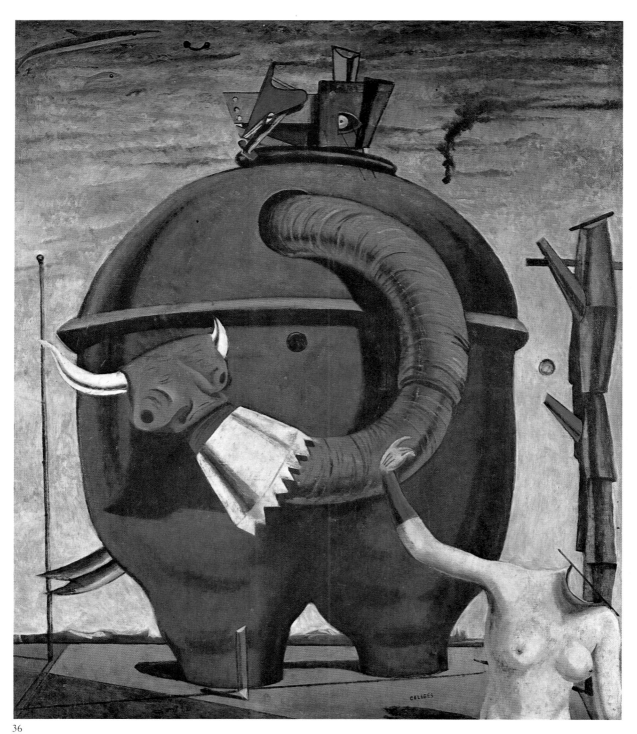

36

35. *Approaching Puberty* or *The Pleiads*. 1921.
Photocollage, gouache and oil on paper, 24.5 × 16.5 cm.
René Rasmussen collection, Paris.

36. *The Elephant of the Celebes*. 1921.
Oil on canvas, 125 × 107 cm.
The Tate Gallery, London.

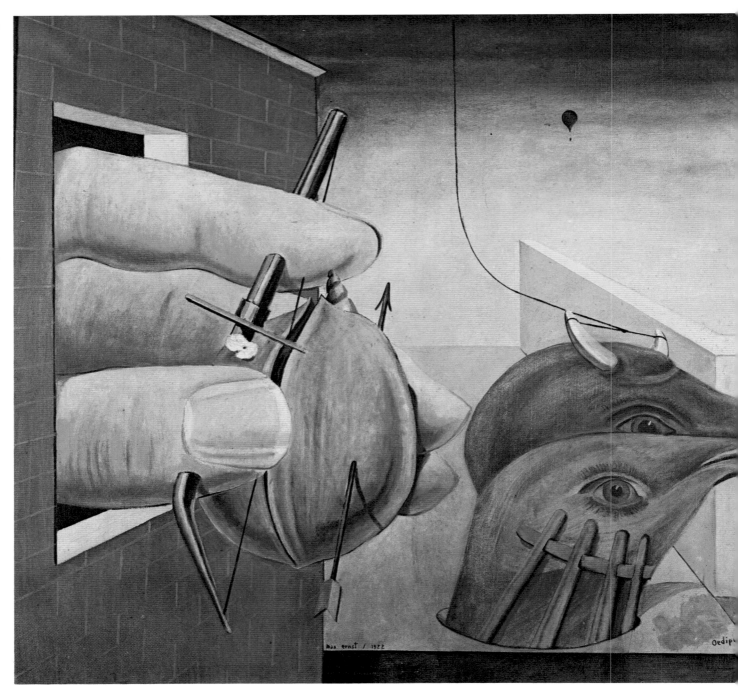

37

37. *Oedipus Rex.* 1922.
 Oil on canvas, 93 × 102 cm.
 Private collection, Paris.

38. *Young Chimera.* 1921.
 Collage, gouache and Indian ink on paper, 26 × 9 cm.
 Simone Breton-Collinet collection, Paris.

39. *The Fall of an Angel.* 1922.
 Collage and oil on paper, 44 × 34 cm.
 Ernst O. E. Fischer collection, Krefeld.

40 *The Couple* or *The Couple in Lace.* 1923.
 Oil on canvas, 101.5 × 142 cm.
 Boymans van Beuningen Museum, Rotterdam.

38

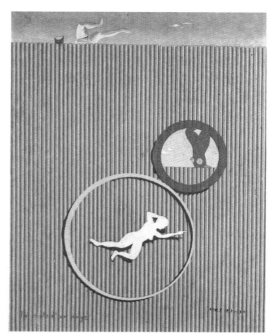

39

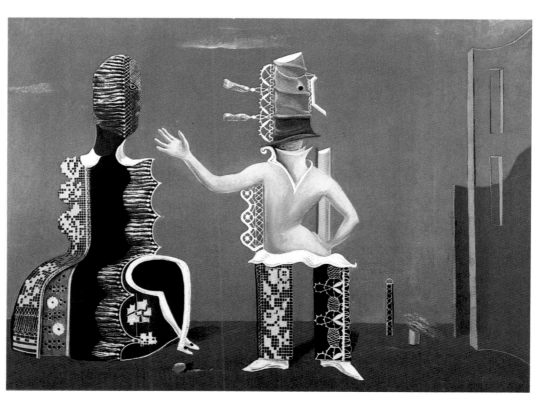

40

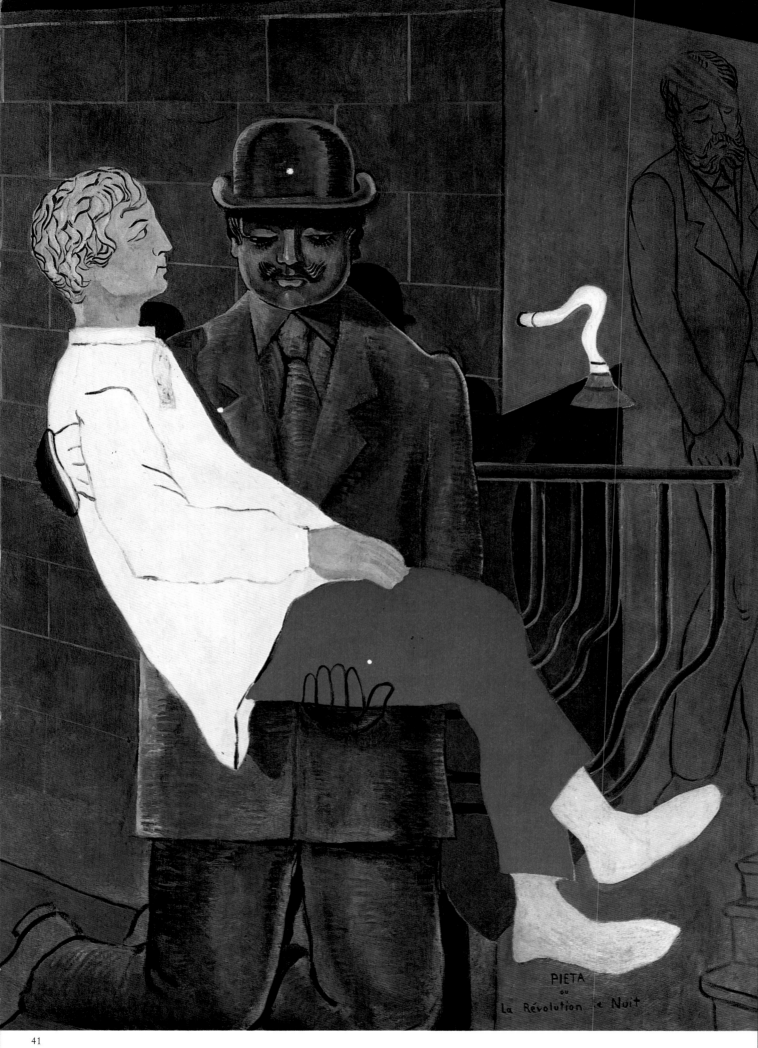

PIETA
ou
La Révolution e Nuit

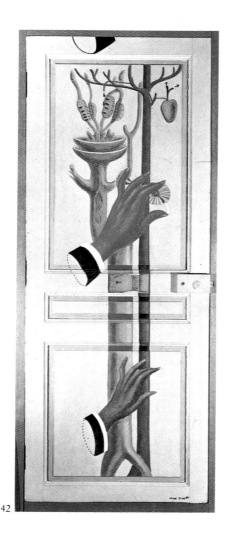

42

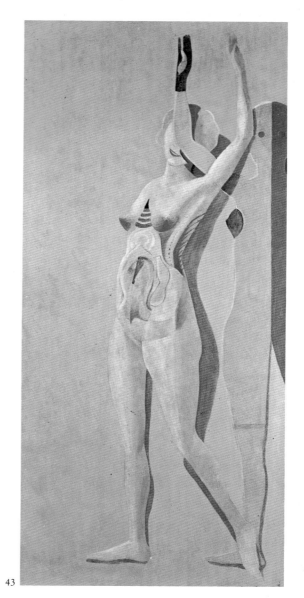

43

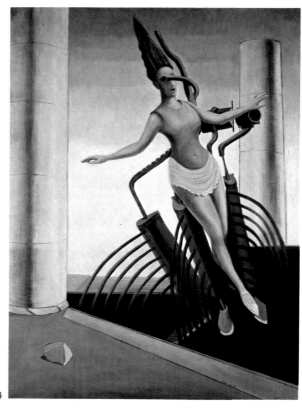

41. *Pietà* or *Revolution by Night*. 1923.
 Oil on canvas, 116 × 89 cm.
 Private collection, Turin.

42. *Untitled*. 1923.
 Door of Paul Éluard's house at Eaubonne.
 Oil on wood, 205 × 80 cm.
 Galerie des Quatre Mouvements, Paris.

43. *Reality Must Not Be Seen as I Am*. 1923.
 Fresco in Paul Éluard's house at Eaubonne,
 later transferred to canvas, 175 × 80 cm.
 Galerie André-François Petit, Paris.

44. *Teetering Woman* or *An Equivocal Woman*. 1923.
 Oil on canvas, 130.5 × 97.5 cm.
 Kunstsammlung Nordrhein-Westfalen, Düsseldorf.

44

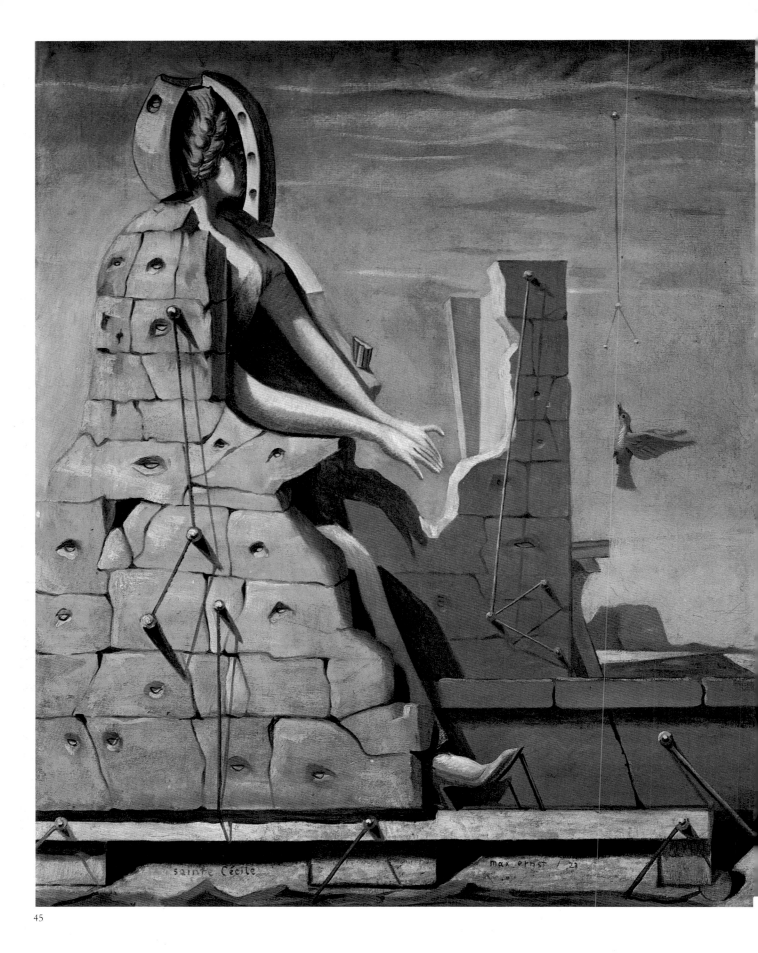

45

45. *Saint Cecilia (The Invisible Piano)*. 1923.
 Oil on canvas, 101 × 82 cm.
 Staatsgalerie, Stuttgart.

46. *At the First Clear Word*. 1923.
 Fresco in Paul Éluard's house at Eaubonne, later transferred to canvas. 232 × 167 cm.
 Kunstsammlung Nordrhein-Westfalen, Düsseldorf.

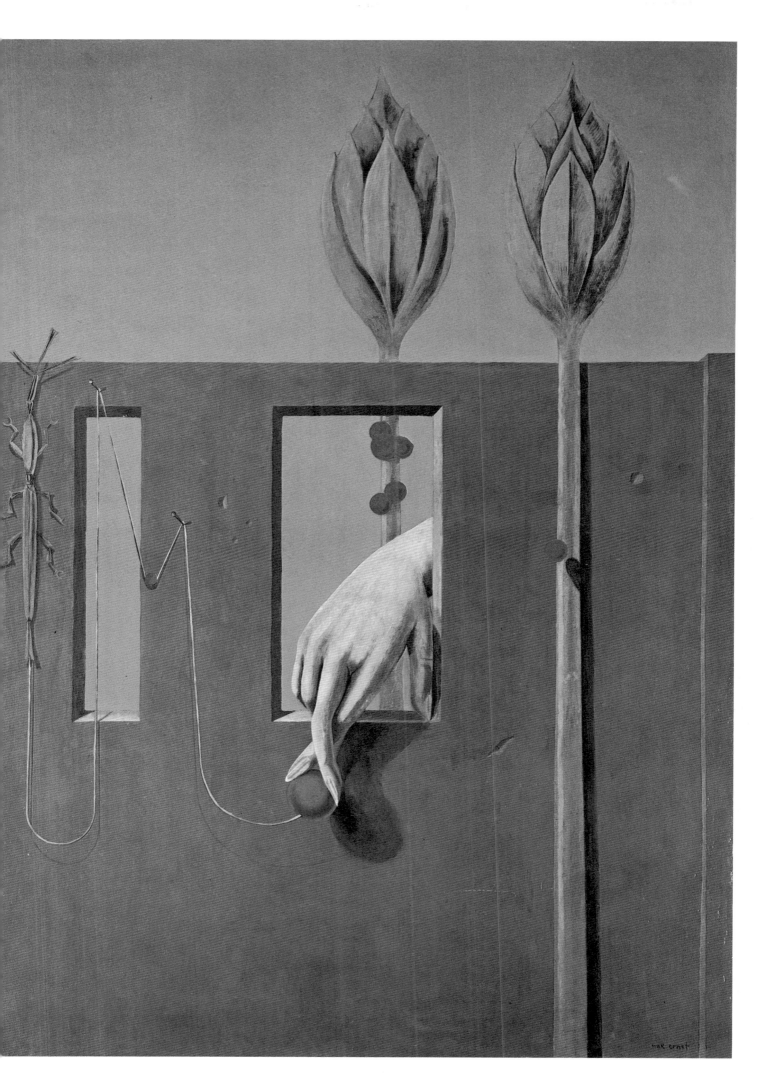

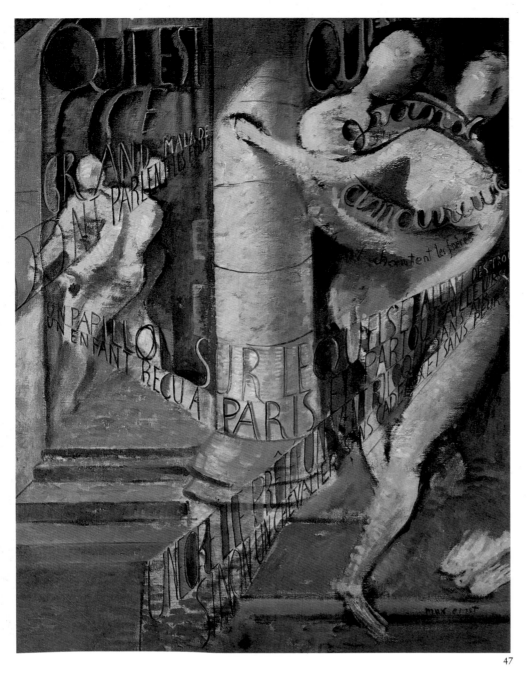

47

48

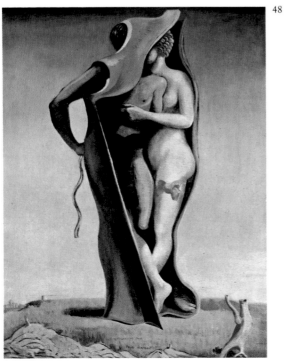

47. *Who Is the Tall Sick Person...?* c. 1923-1924.
Oil on canvas, 65.4 × 50 cm.
Siegfried Adler collection, Montagnola.

48. *Long Live Love* or *Charming Countryside*. 1923.
Oil on canvas, 131.5 × 98 cm.
Morton D. May collection, St. Louis.

49. *Ubu Imperator*. 1923.
Oil on canvas, 100 × 81 cm.
Hélène Anavi collection, Paulhiac.

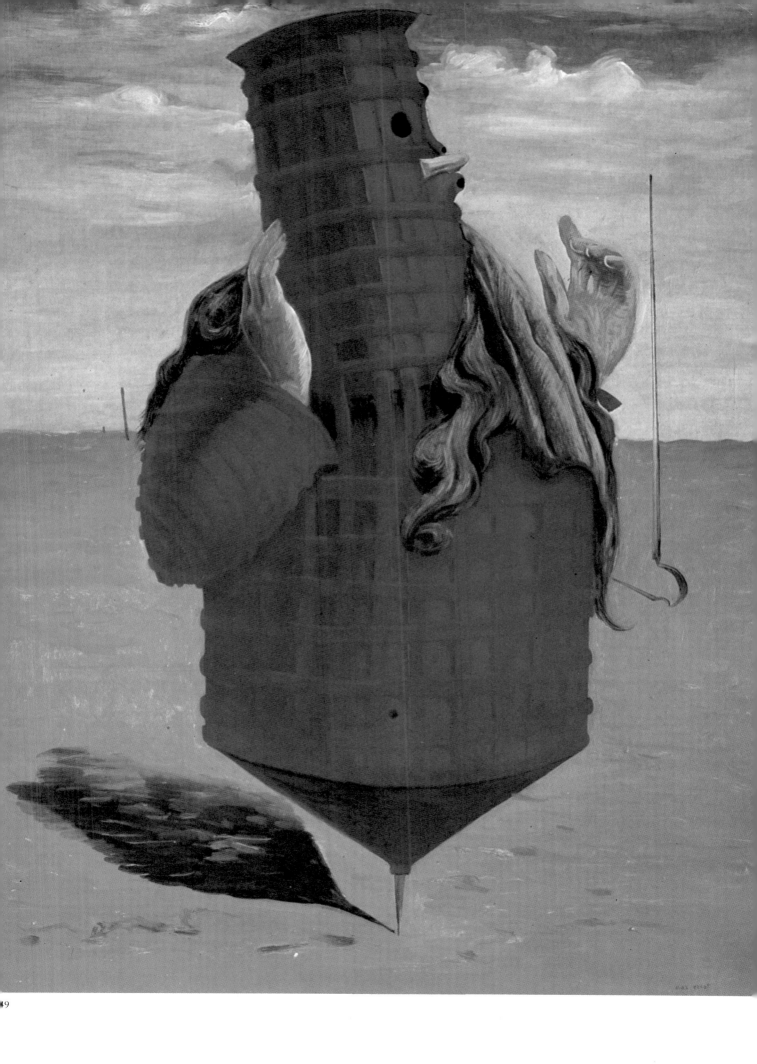

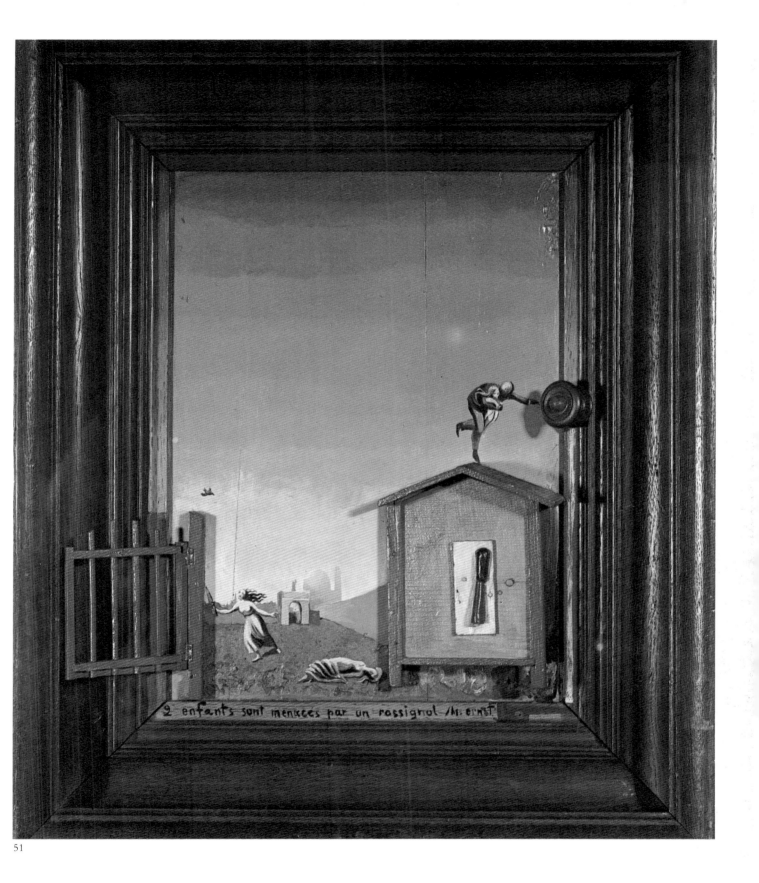

51

50. *Dadaville. c. 1924.*
 Painted plaster of Paris and cork on canvas 66 × 56 cm.
 Roland Penrose collection, London.

51. *Two Girls Are Threatened by a Nightingale.* 1924.
 Oil on wood, with wooden elements added, 69.8 × 57 × 11.4 cm.
 The Museum of Modern Art, New York.

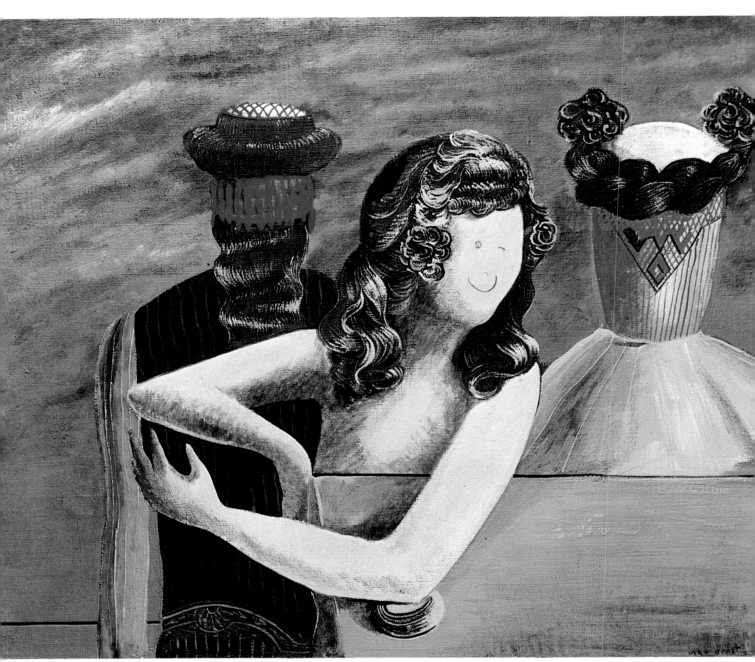

52

52. *Sunday Guests*. 1924.
 Oil on canvas, 55 × 65 cm.
 Henri Parisot collection, Sceaux.

53. *Portrait M* or *The Letter*. 1924.
 Oil on canvas, 83 × 62 cm.
 Ernst Beyeler Gallery, Basel.

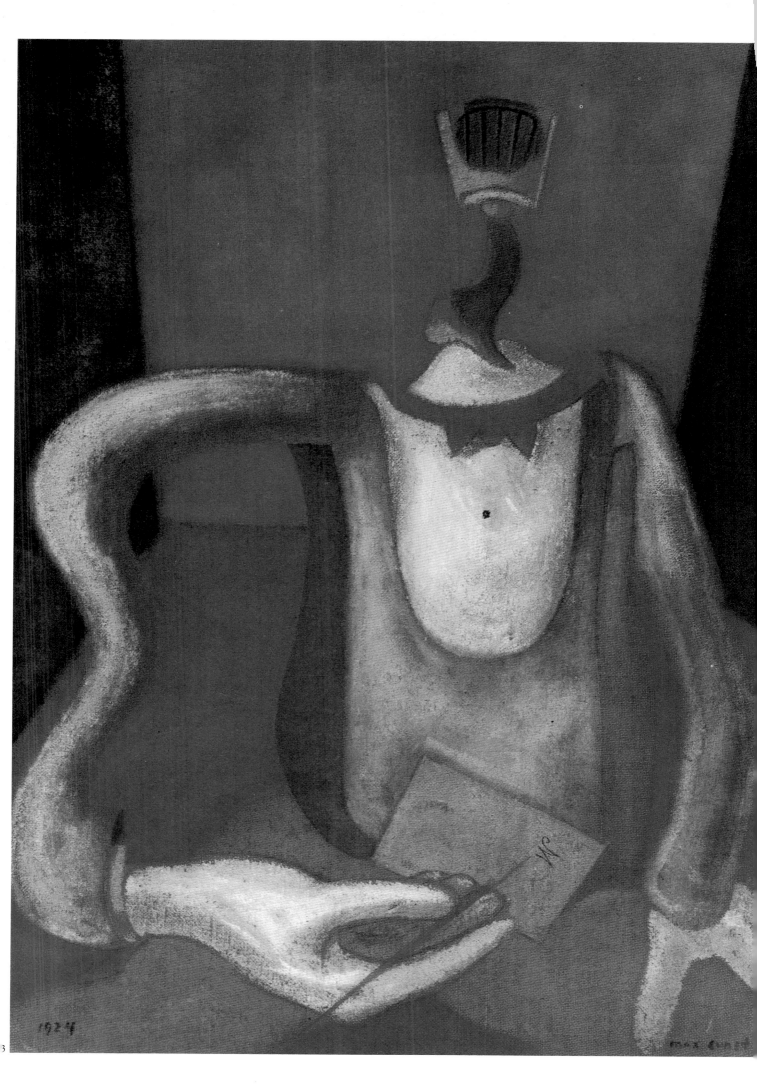

1924

max ernst

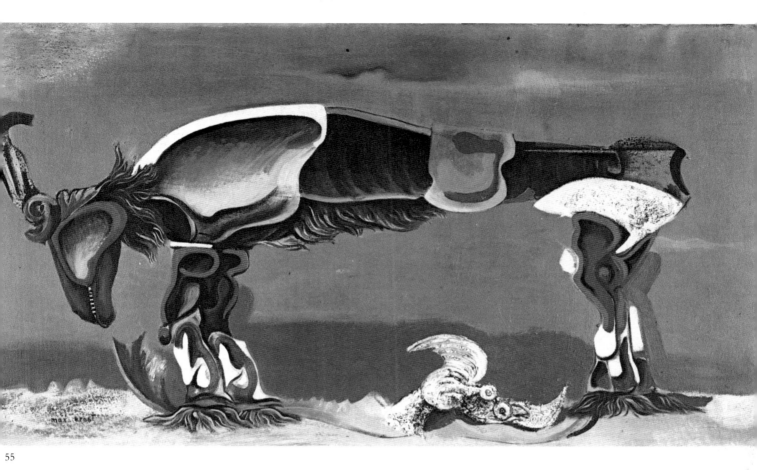

55

54. *The Couple* or *The Embrace*. 1924.
 Oil on canvas, 73 × 54 cm.
 Mrs. Jean Krebs collection, Brussels.

55. *The Beautiful Season*. 1925.
 Oil on canvas, 58 × 108 cm.
 Bonomi collection.

56. *Portrait of Gala*. 1924.
 Oil on canvas, 81.5 × 65.4 cm.
 Muriel Kallis Newman collection, Chicago.

56

57

58

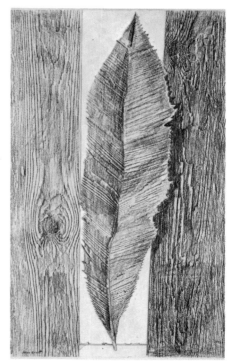

59

57. *Untitled*. 1925.
Frottage, pencil on paper.

58. *The Forest*. 1925.
Oil on canvas, 115.5 × 73.5 cm.
Jan Krugier Gallery, Geneva.

59. *Leaf Customs*. 1925.
Frottage, pencil on paper, 42.7 × 26 cm.
Ernst Fischer collection, Krefeld.

60. *Two Sisters*. 1926.
Oil on canvas and frottage in black lead-pencil, 100.3 × 73 cm.
De Ménil Family collection, Houston.

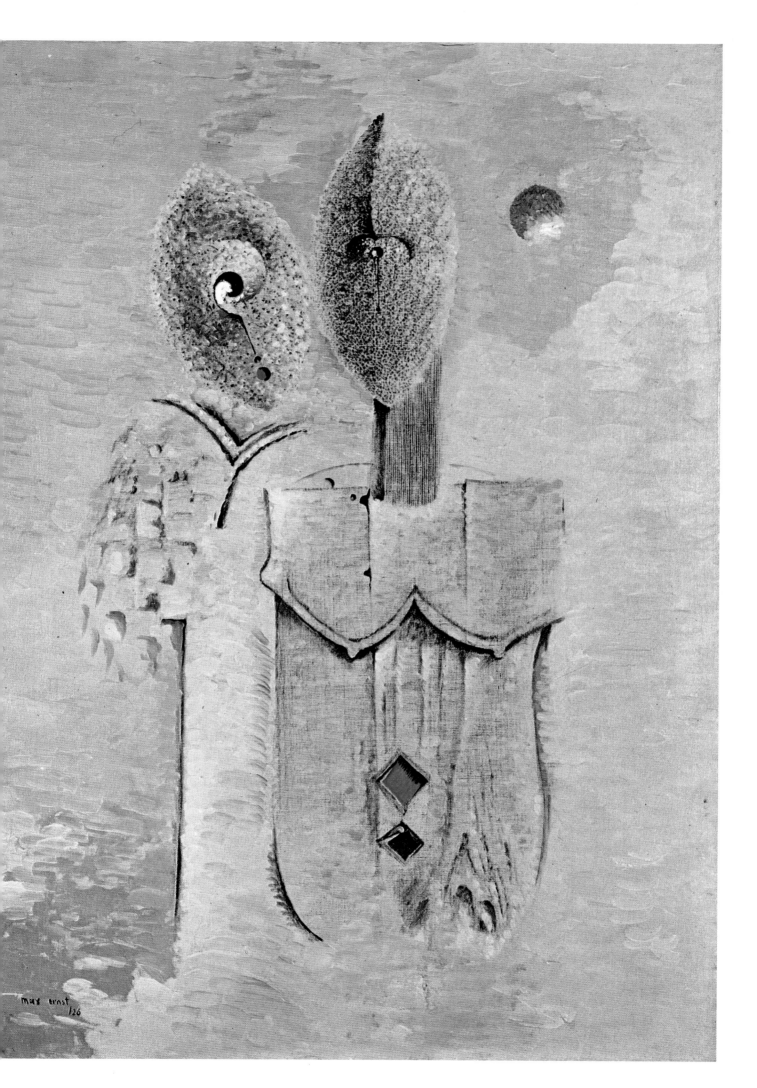

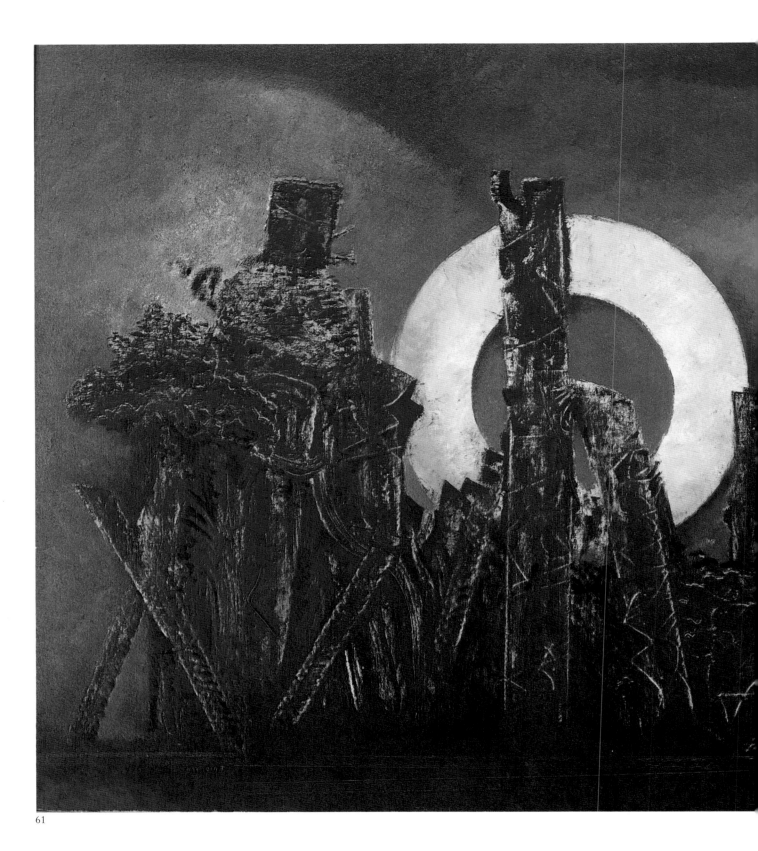

61

61. *The Great Forest.* 1927.
Oil on canvas, 114.5 × 146.5 cm.
Kunstmuseum, Basel.

62. *Dark Forest and Bird.* 1926.
Oil on canvas, 65.5 × 81.5 cm.
Private collection, U.S.A.

63. *Forest, Bird, Sun.* 1926.
Private collection.

64. *Forest.* 1927-1928.
Oil on canvas, 27 × 22 cm.
Jan Krugier Gallery, Geneva.

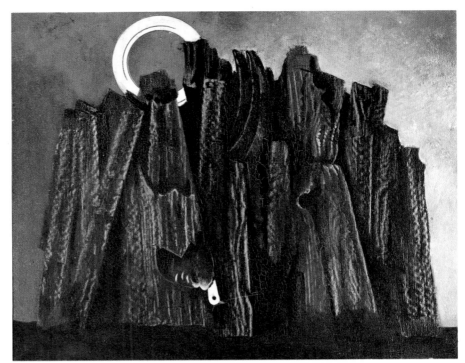

62

63

64

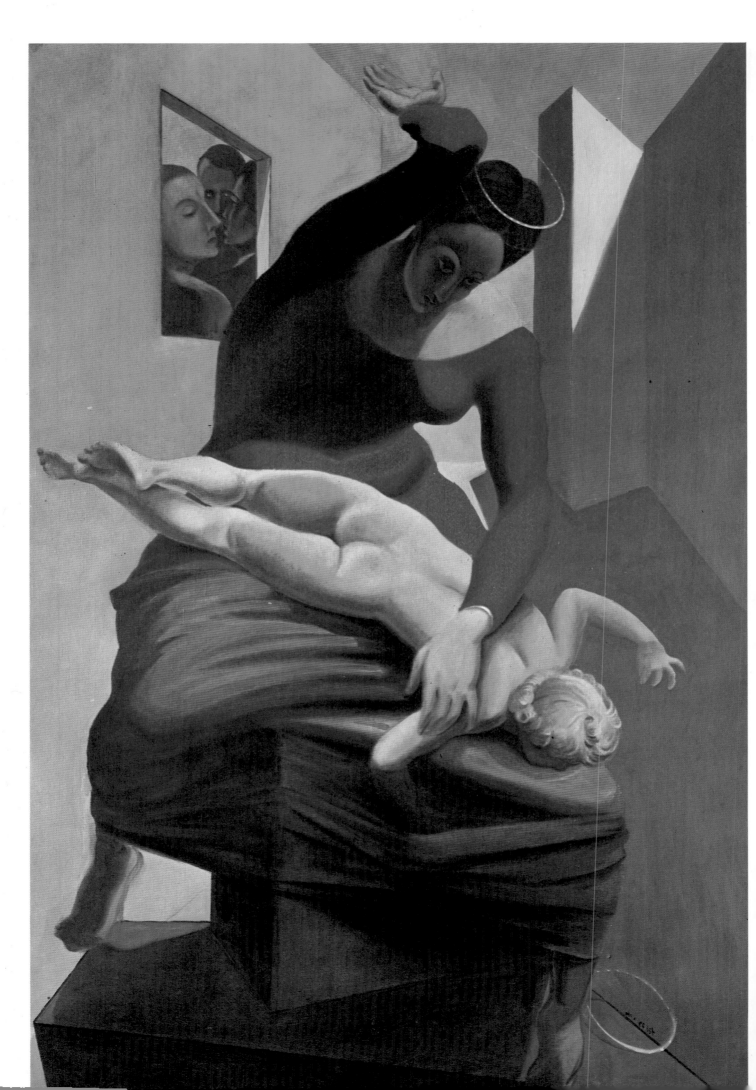

66

67

65. *The Blessed Virgin Chastising the Child Jesus Before Three Witnesses: A.B.* [André Breton], *P.E.* [Paul Éluard] *and the artist.* 1926. Oil on canvas, 196 × 130 cm. Mrs Jean Krebs collection, Brussels.

66. *Earth-Beam, the Sea and the Sun.* 1927. J. B. Urvater collection, Paris.

67. *Monument to the Birds.* 1927. Oil on canvas, 162 × 130 cm. Private collection.

68. *Child, Horse, Flower and Snake.* 1927. Oil on canvas, 71.5 × 82 cm. HAG Kunststiftung collection, Zürich.

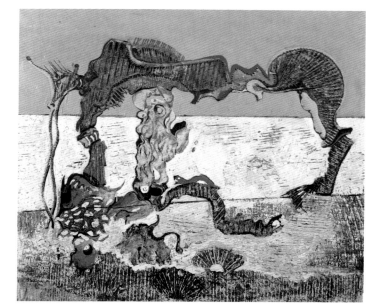

68

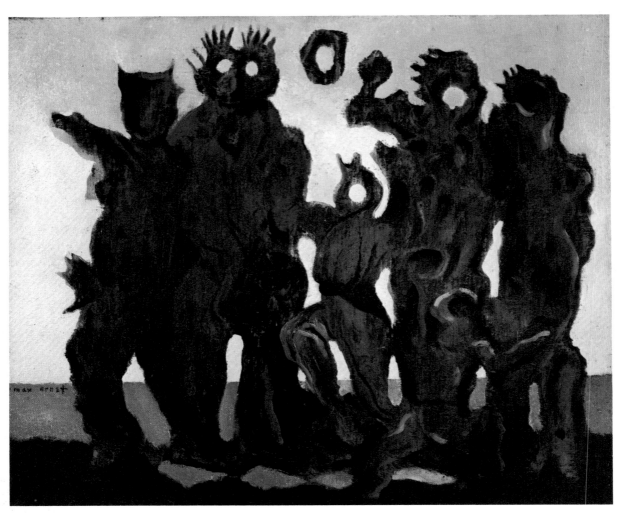

69

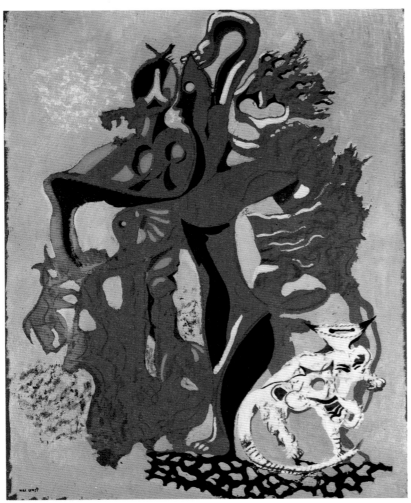

70

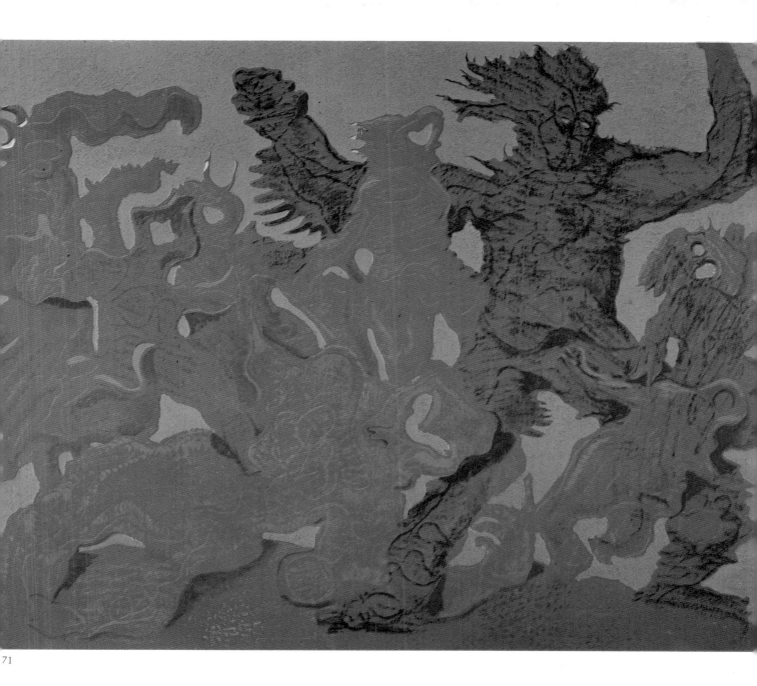

71

69. *They Have Slept too Long in the Forest.* 1927.
 Oil on canvas, 46 × 55 cm.
 Evelyne Lévy collection, Paris.

70. *The Family.* 1927.
 Oil on canvas, 81.5 × 66 cm.
 Ernst Beyeler Gallery, Basel.

71. *The Horde.* 1927.
 Oil on canvas, 114 × 146 cm.
 Stedelijk Museum, Amsterdam.

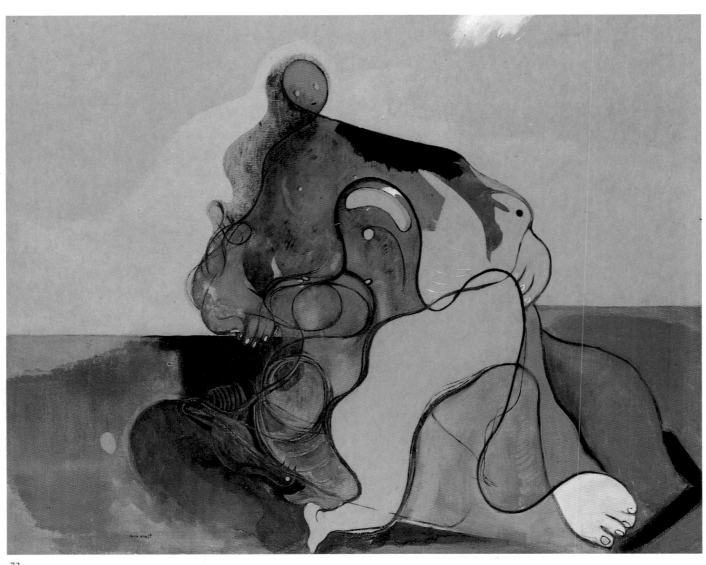

72

73

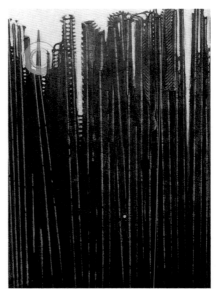

74

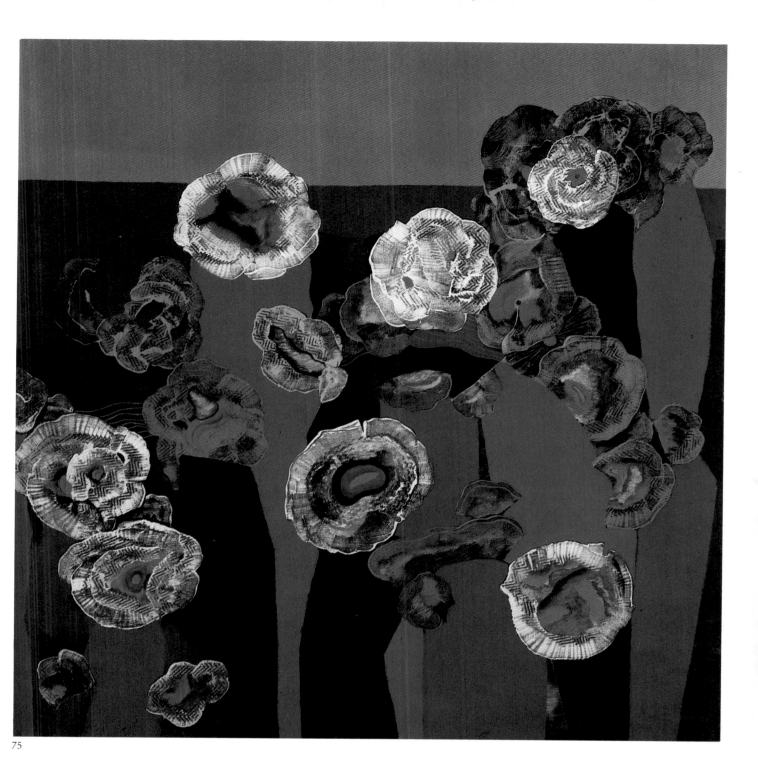

75

72. *The Kiss.* 1927.
 Oil on canvas, 60 × 128 cm.
 Peggy Guggenheim collection, Venice.

73. *The Forest.* c. 1928.
 Oil on canvas, 27 × 34.8 cm.
 Sprengel collection, Hanover.

74. *Forest.* 1929.

75. *Shell Flowers.* 1929.
 Oil on canvas, 129 × 129 cm.
 Musée National d'Art Moderne de Paris.

76. *Fishbone Forest.* 1929.
 Oil on canvas, 54 × 65 cm.
 Ernst Beyeler Gallery, Basel.

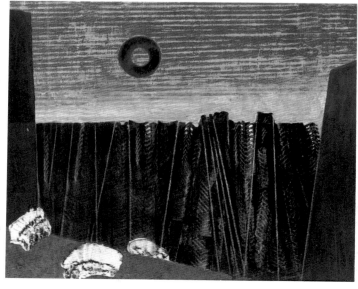

76

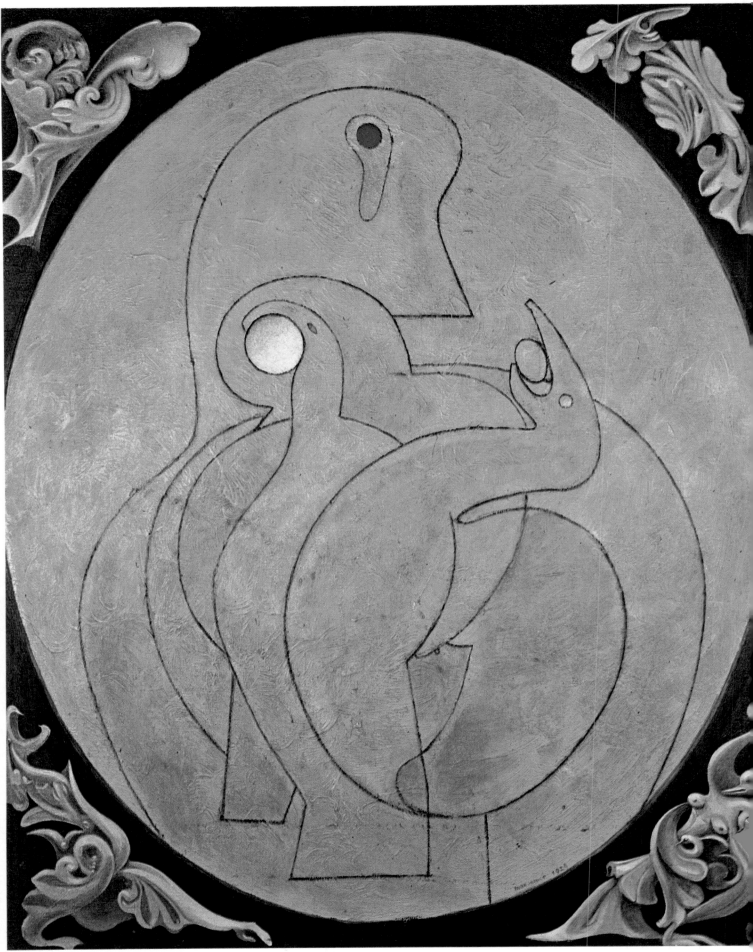

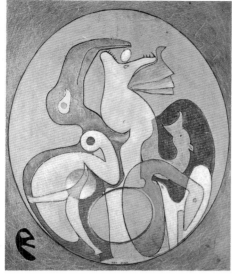

78

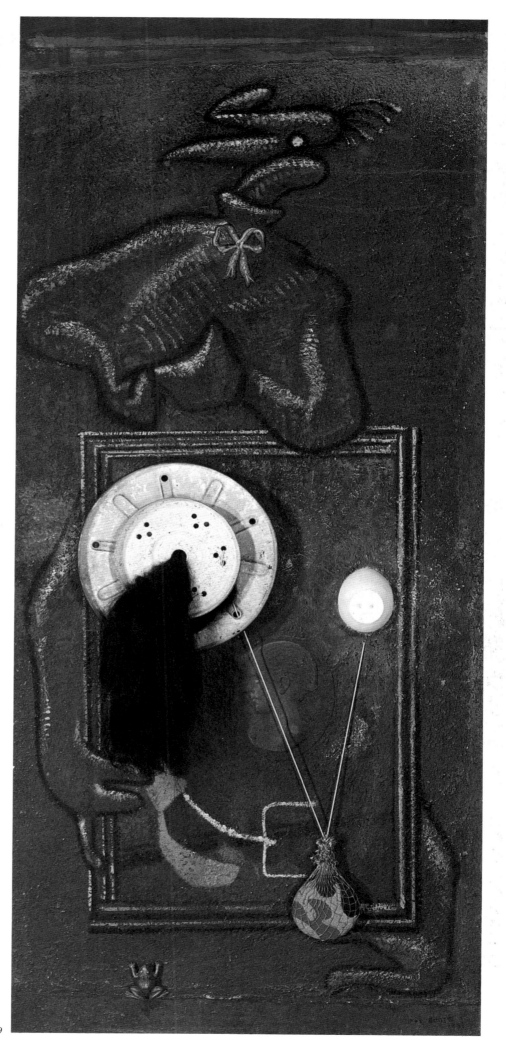

77. *Inside Sight: the Egg.* 1929.
 Oil on canvas, 98.5 × 79.4 cm.
 De Ménil Family collection,
 Houston.

78. *Inside Sight.* 1929.
 Oil on canvas, 120 × 100 cm.
 Private collection, Paris.

79. *Loplop Introduces a Young Girl.*
 1930.
 Oil and different materials on wood,
 175 × 89 cm.
 The artist's collection.

79

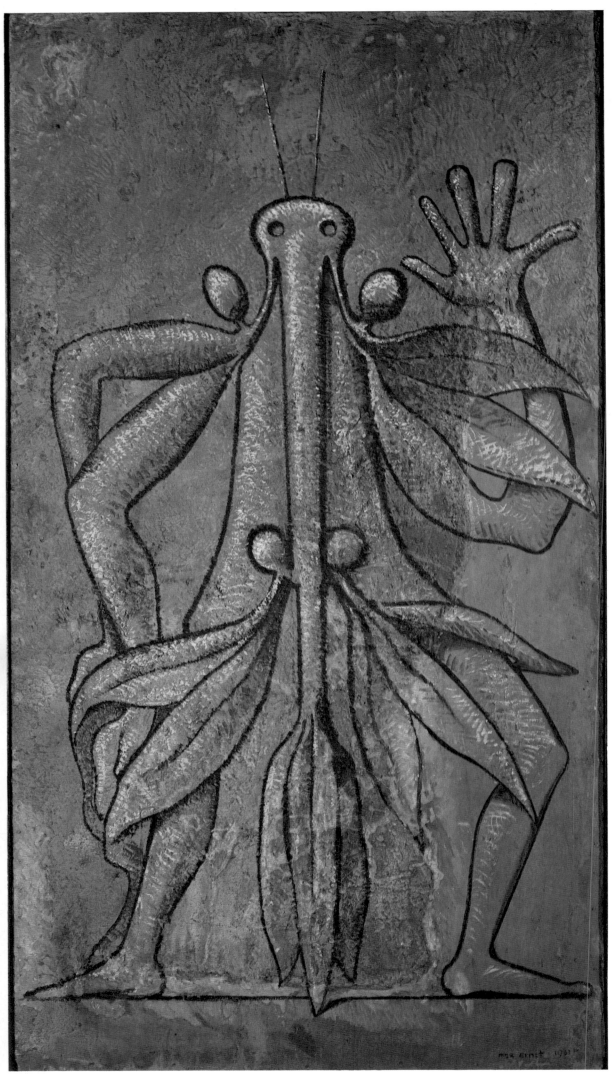

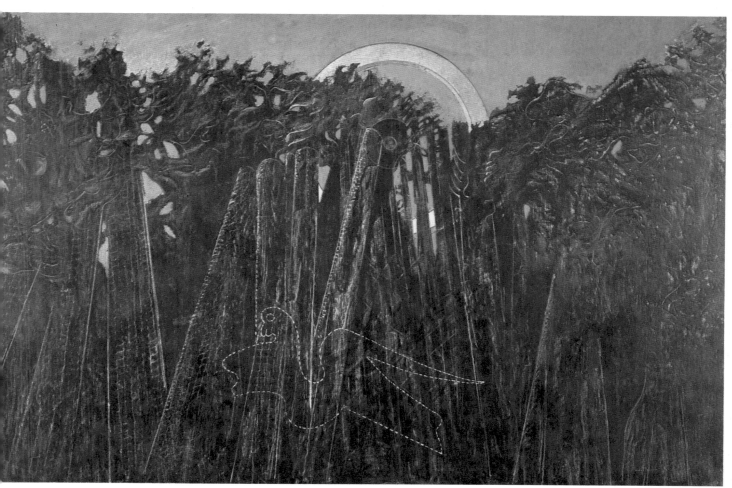

81

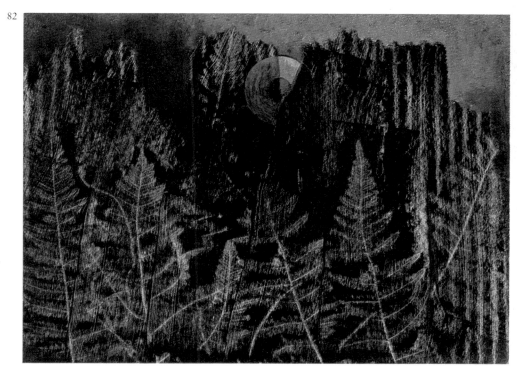

82

80. *Human Form*. 1931.
 Oil on gesso on wood, 183 × 100 cm.
 Moderna Museet, Stockholm.

81. *La Foresta Imbalsamata*. 1933.
 Oil on canvas, 162 × 253 cm.
 De Ménil Family collection, Houston.

82. *Forest and Sun*. 1932.
 Oil on paper, 22.5 × 31 cm.
 Dr and Mrs Henry Roland collection.

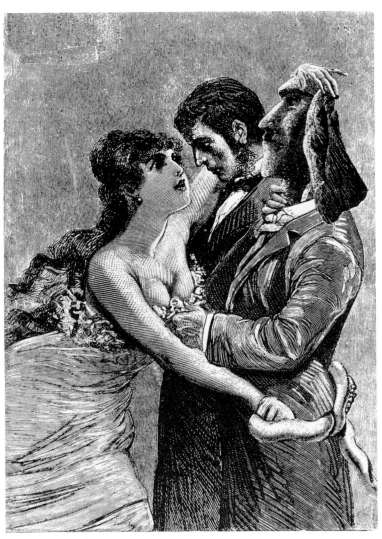

83

85

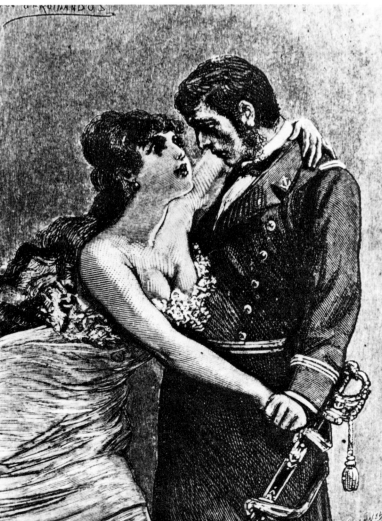

84

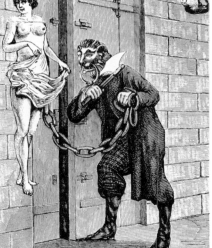

86

83. Collage by Max Ernst for *A Week of Kindness*. Editions Jeanne Bucher, 1934.

84. Illustration by Jules Mary for *Les damnés de Paris*. Paris, J. Rouff éditeur, 1883. Starting-point for the collage in Max Ernst's illustration (Fig. 83).

85 & 86. *A Week of Kindness* or *The Seven Capital Elements*. 1934. Collage-novel.

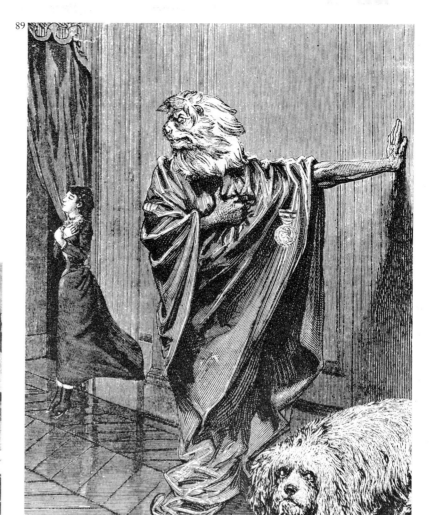

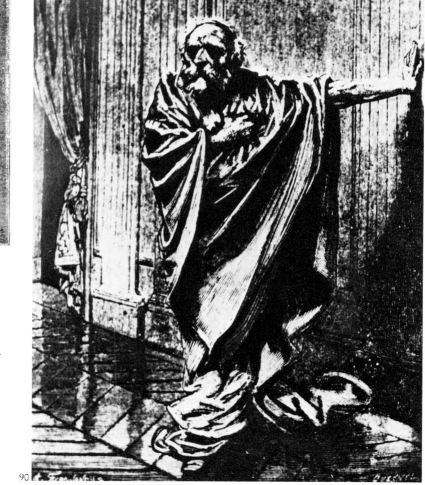

87 & 88. *A Week of Kindness* or *The Seven Capital Elements*. 1934.
Collage-novel.

89. Collage by Max Ernst for *A Week of Kindness*, 1934.

90. Illustration by Jules Mary for *Les damnés de Paris*, 1883. Starting-point for the collage in Max Ernst's illustration (Fig. 89).

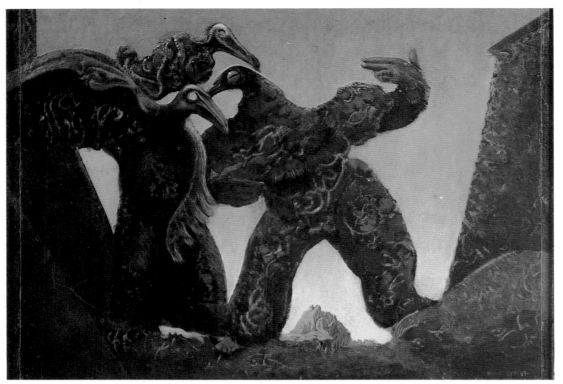

91

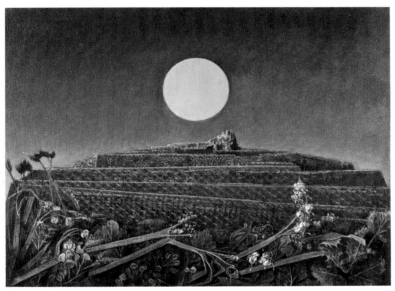

92

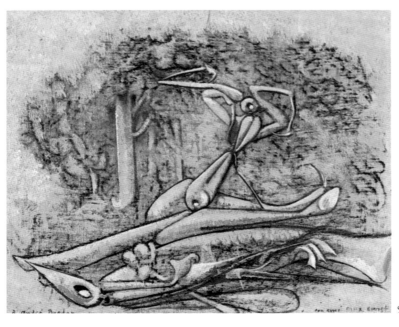

93

91. *Barbarians Marching Westward.* 1935.
Oil on paper, 24 × 32 cm.
Private collection, New York.

92. *The Entire City.* 1935-1936.
Oil on canvas, 60 × 80 cm.
Kunsthaus, Zürich.

93. *Hunger Feasts.* 1935.
Oil on canvas, 19 × 24.2 cm.
De Ménil Family collection, Houston.

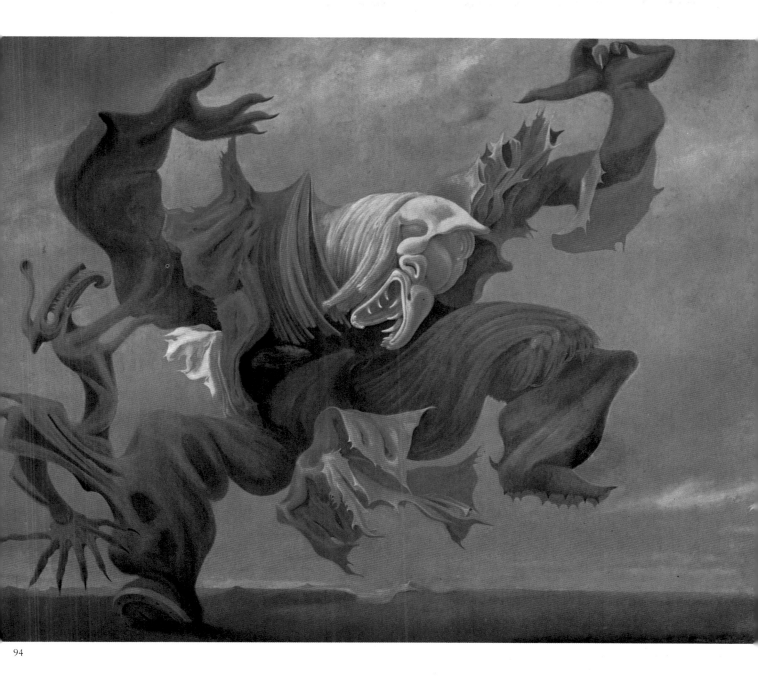

94

94. *The Angel of Hearth and Home.* 1937.
Oil on canvas, 112.5 × 144 cm.
Private collection.

95. *The Nymph Echo.* 1936.
Oil on canvas, 46 × 55 cm.
The Museum of Modern Art, New York.

96. *Lust for Life.* 1936.
Oil on canvas, 72 × 91 cm.
Roland Penrose collection, London.

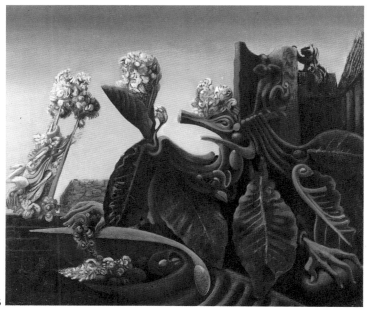

95

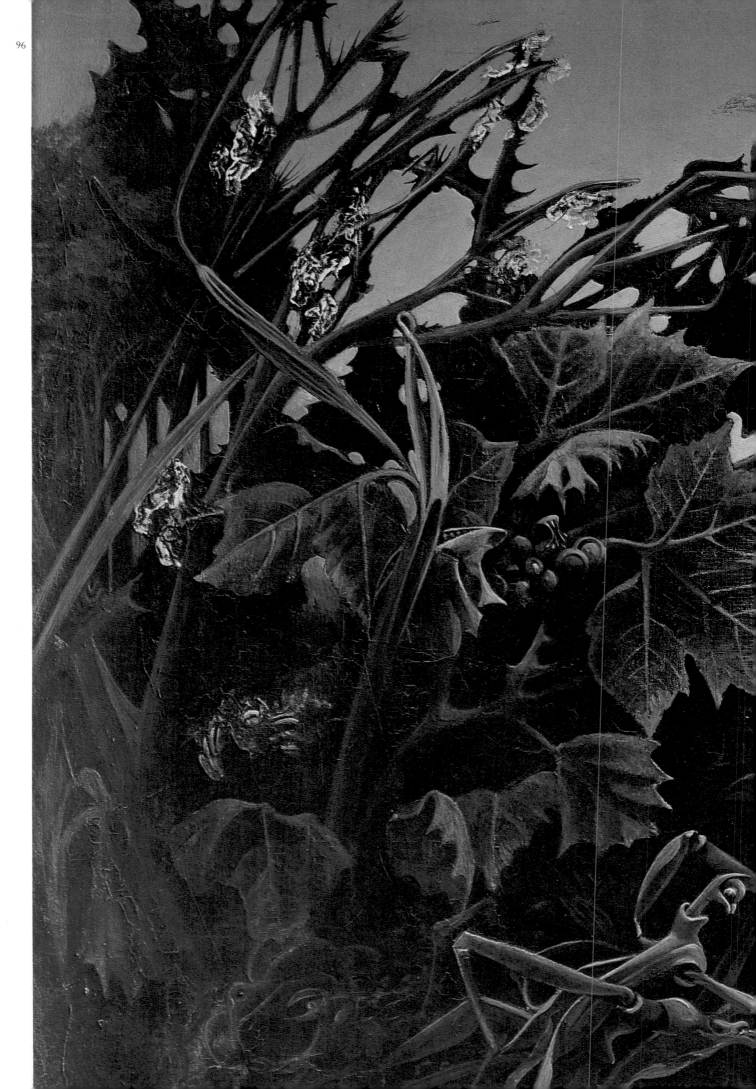

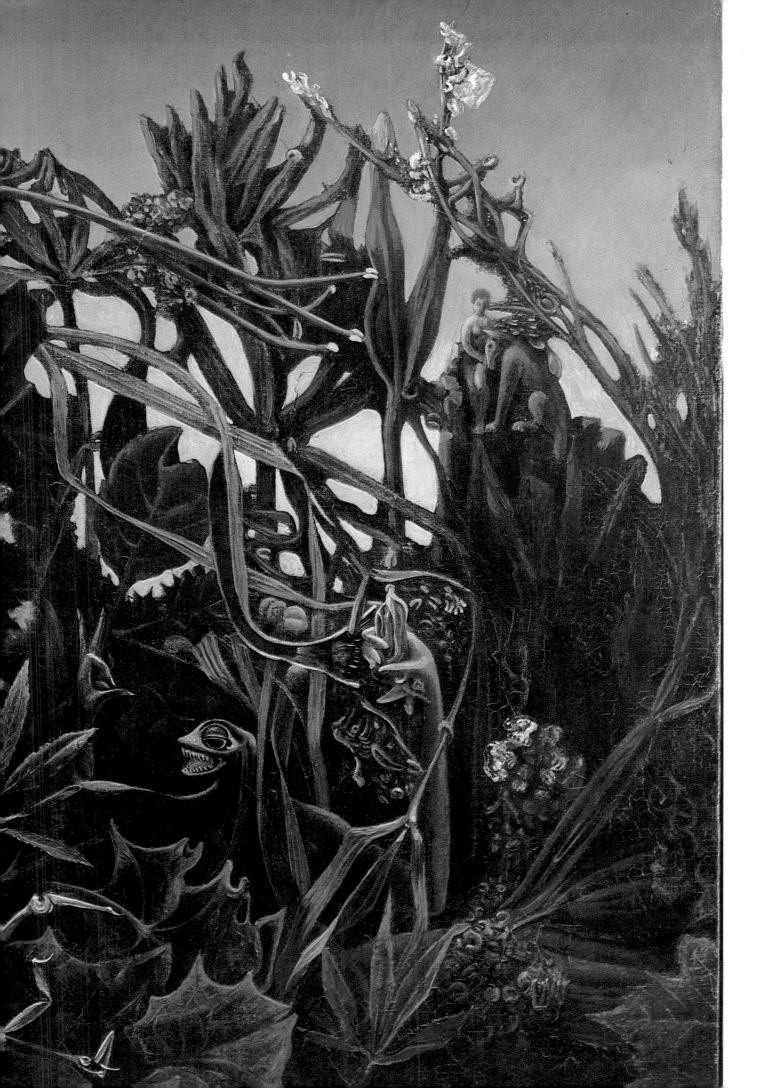

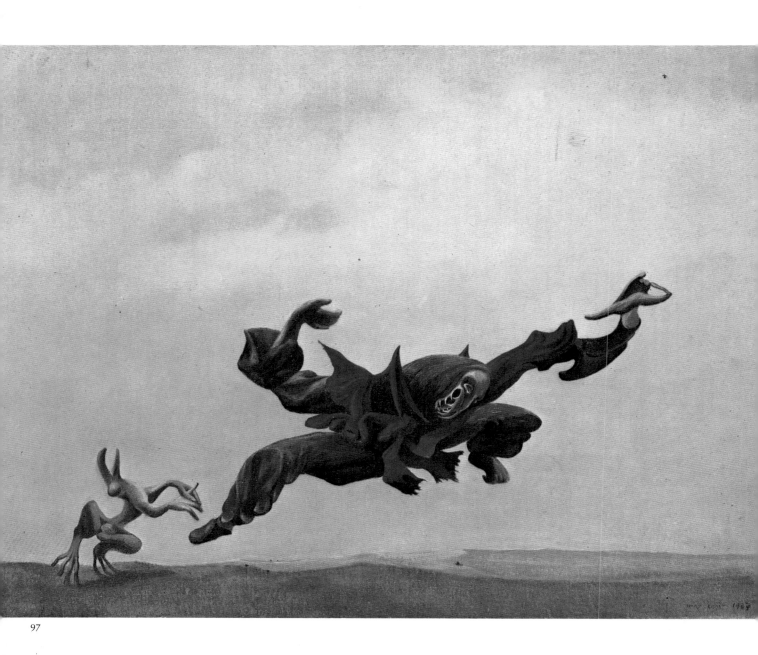

97

97. *The Angel of Hearth and Home.* 1937.
Oil on canvas, 54 × 74 cm.
Jan Krugier Gallery, Geneva.

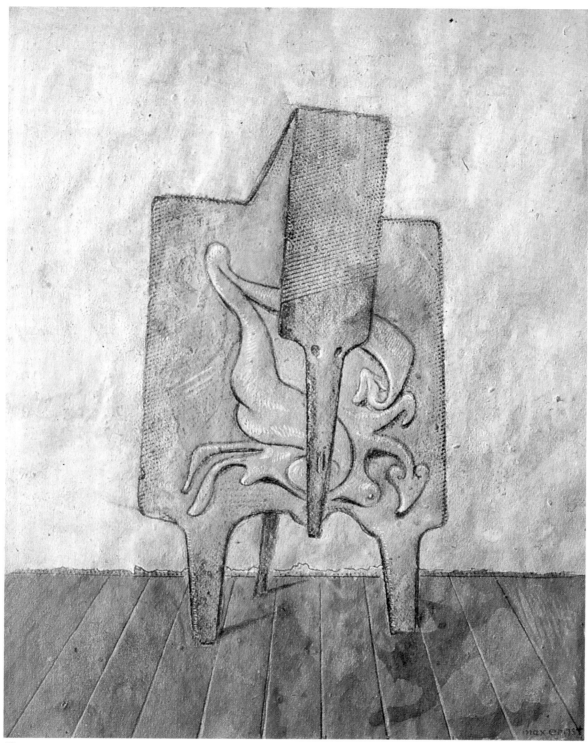

98

98. *Human Figure (Les Milles)*. 1939.
Frottage and gouache, 60 × 47 cm.
Brooks Jackson collection.

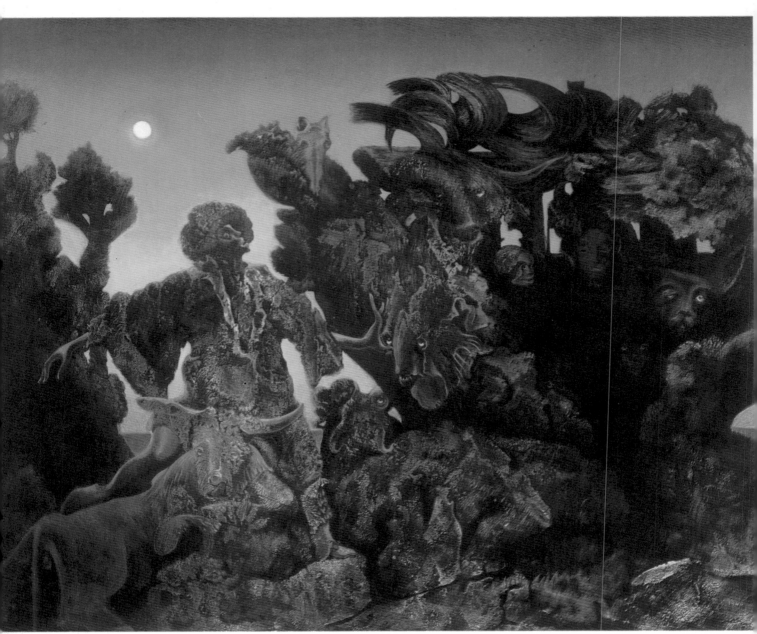

99

99. *Epiphany.* 1940.
 Oil on canvas, 52 × 64 cm.
 Richard Feigen Gallery, New York.

100. *The Robing of the Bride.* 1939.
 Painting on wood, 130 × 96 cm.
 Peggy Guggenheim collection, Venice.

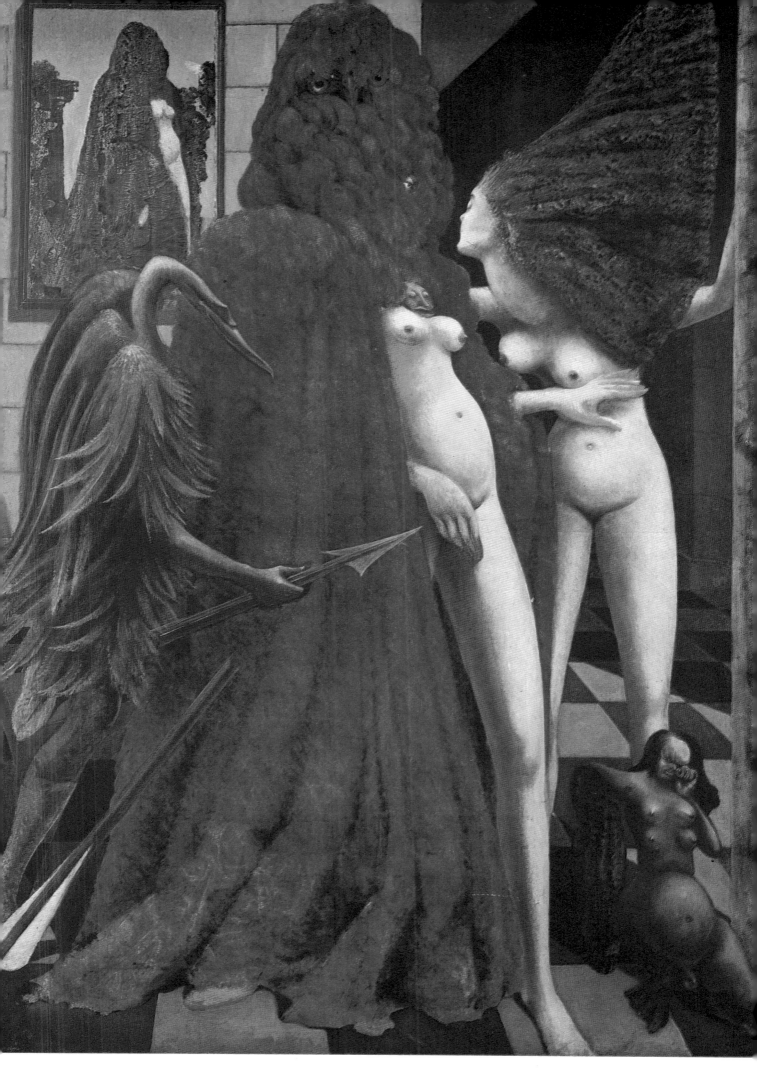

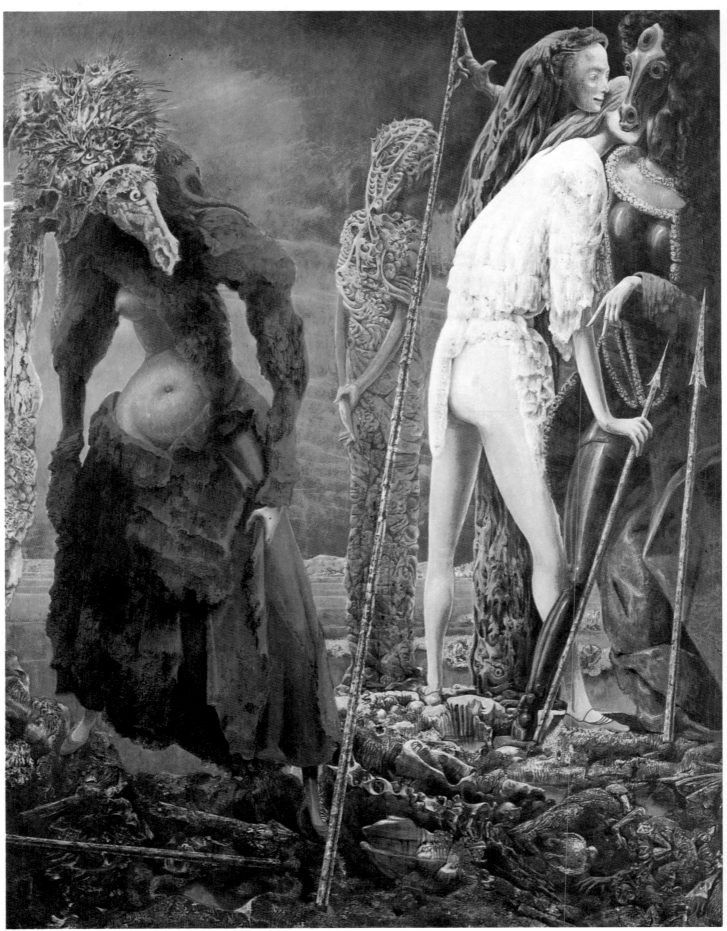

102

103

104

101. *The Antipope*. 1941-1942.
Oil on canvas, 160 × 127 cm.
Peggy Guggenheim collection, Venice.

102. *Desert*. 1940.
Oil on canvas, 15 × 20.5 cm.
Jan Krugier Gallery, Geneva.

103. *Marlene (Woman and Child)*.
December 1940-January 1941.
Oil on canvas, 23.8 × 19.5 cm.
De Ménil Family collection, Houston.

104. *The Witch*. 1941.
Oil on canvas.
Alfred Barr collection, New York.

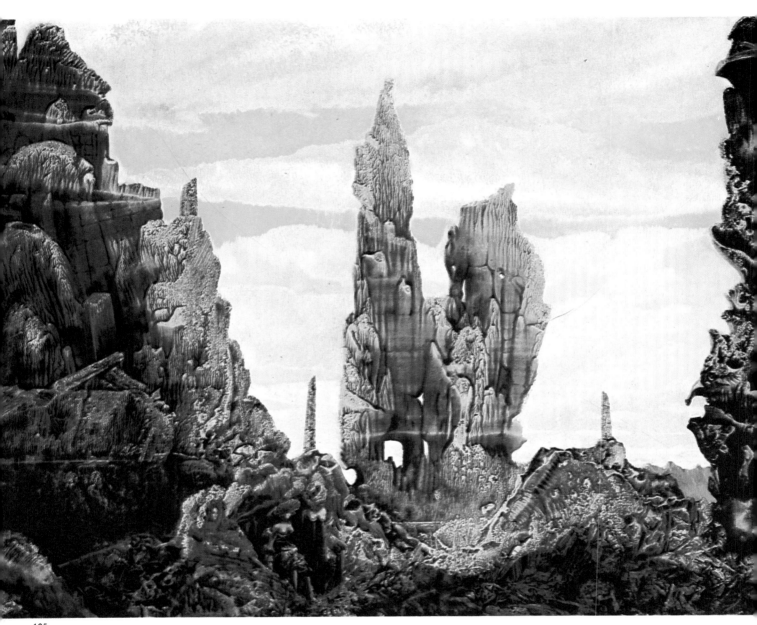

105. *Europe After the Rain II.* 1940-1942.
Oil on canvas, 54 × 145.5 cm.
Wadsworth Athenaeum, Hartford, The Ella Gallup Sumner
and Mary Carlin Sumner Collection.

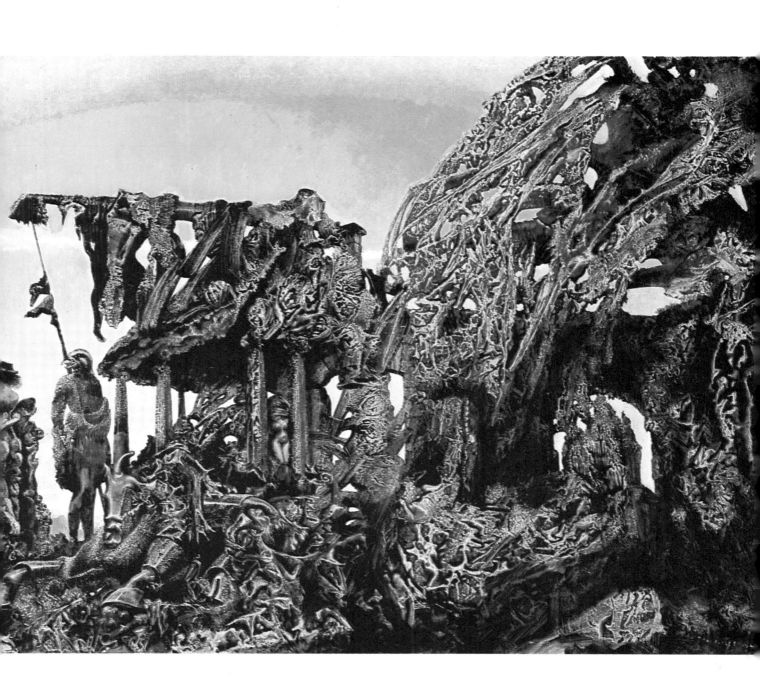

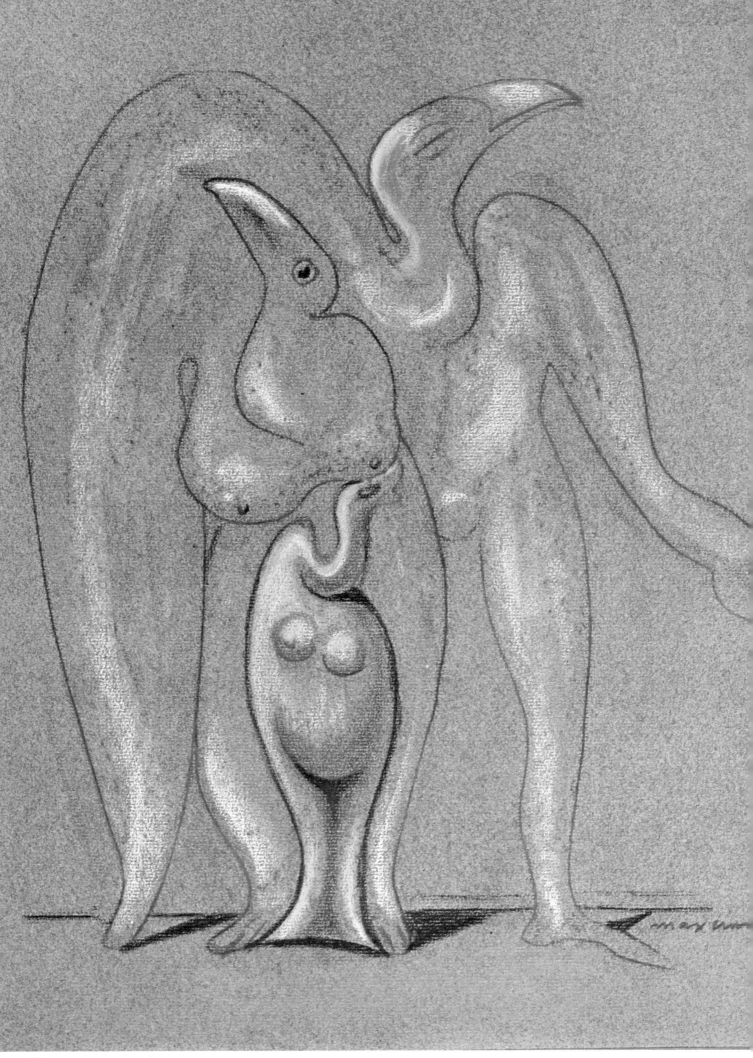

107

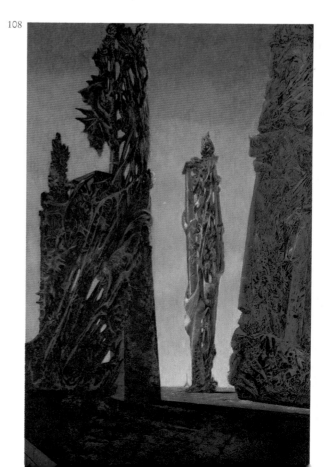

108

106. *The Nation of the Birds.* 1941.
Pastel on paper, 46 × 33 cm.
Private collection.

107. *Day and Night.* 1941-1942.
Oil on canvas, 112 × 146 cm.
Private collection.

108. *Torpid Town.* 1943.
Oil on canvas, 120 × 74 cm.
Private collection.

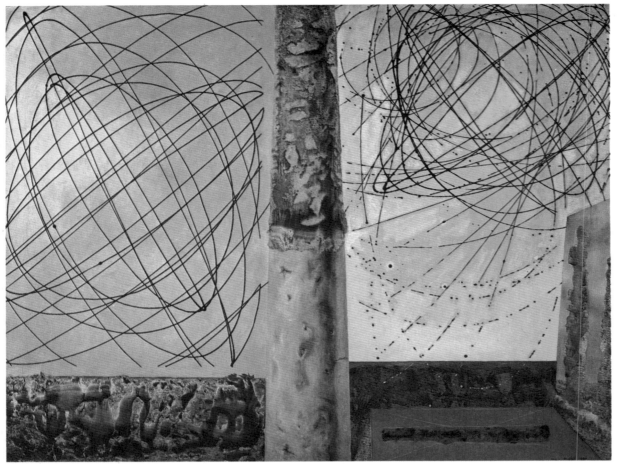

109

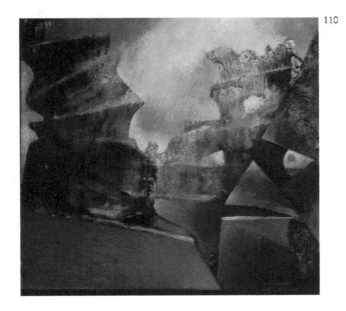

110

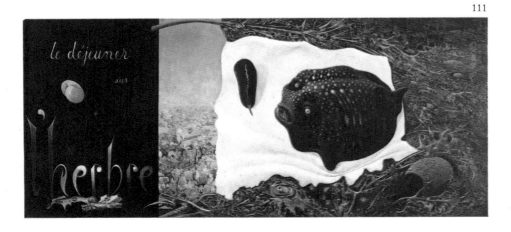

111

109. *The Bewildered Planet.* 1942.
Oil on canvas, 119 × 140 cm.
The Tel-Aviv Museum.

110. *Arizona Landscape.* 1943.
Oil on wood, 36.5 × 34.5 cm.
Jan Krugier Gallery, Geneva.

111. *The Luncheon on the Grass.* 1944.
Oil on canvas, 68 × 150 cm.
Private collection.

112. *The Cocktail Drinker.* 1945.
Oil on canvas, 116 × 72.5 cm.
Kunstsammlung Nordrhein-Westfalen,
Düsseldorf.

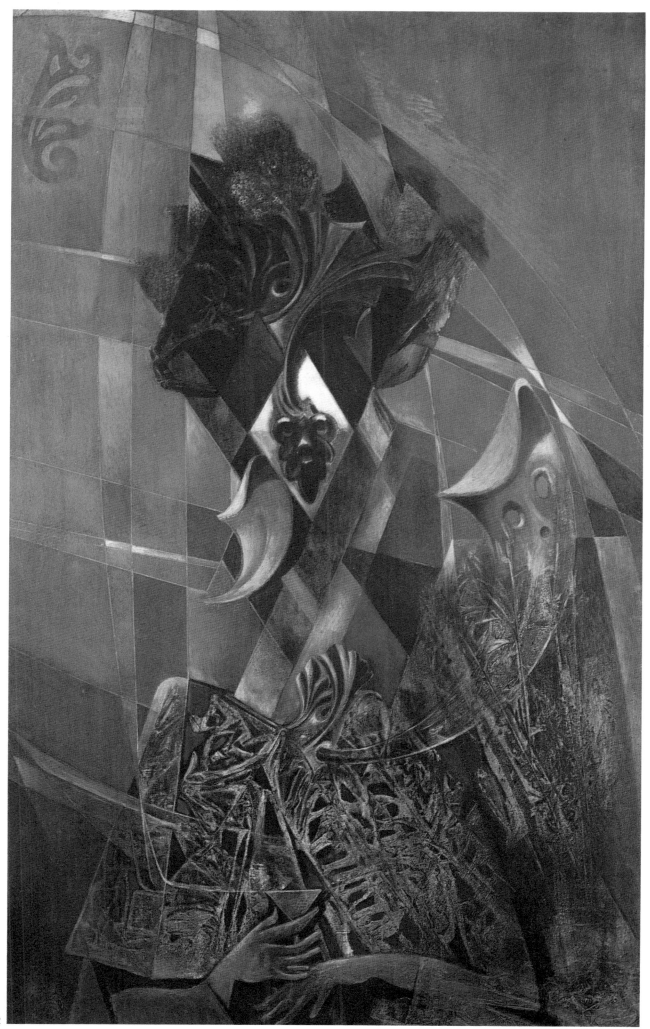

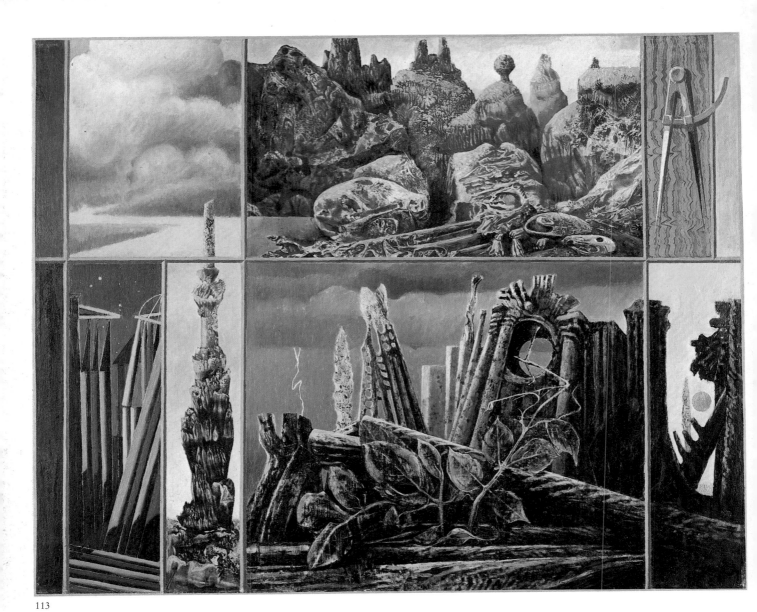

113

114

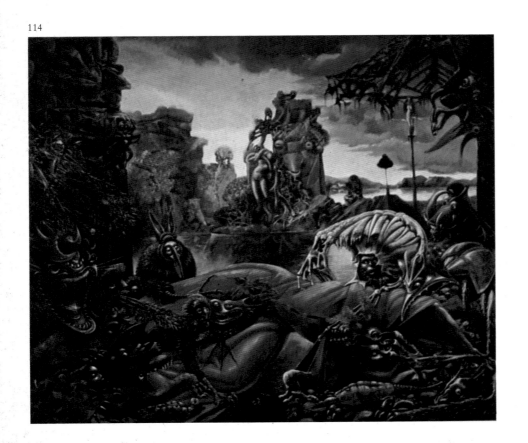

113. *Painting for Young People.* 1943.
Oil on canvas, 61 × 76 cm.
Jan Krugier Gallery, Geneva.

114. *The Temptation of Saint Anthony.*
1945.
Oil on canvas, 108 × 128 cm.
Wilhelm-Lehmbruck-Museum der
Stadt Duisburg.

115. *The Temptation of Saint Anthony.*
(Detail). 1945.

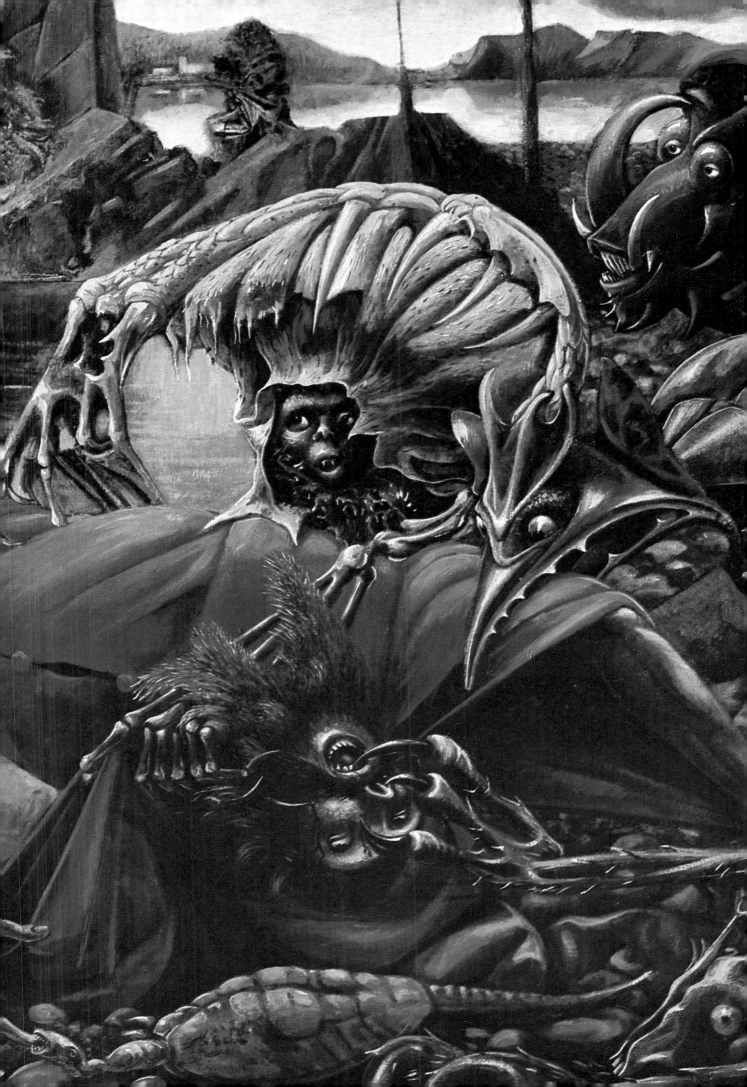

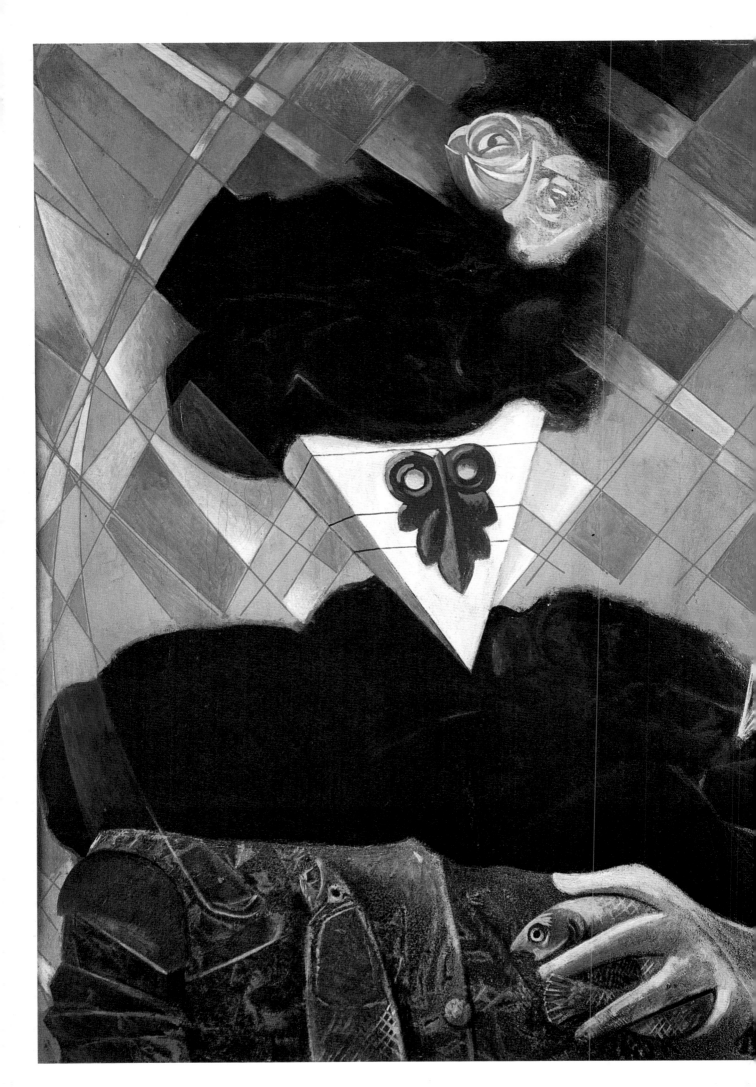

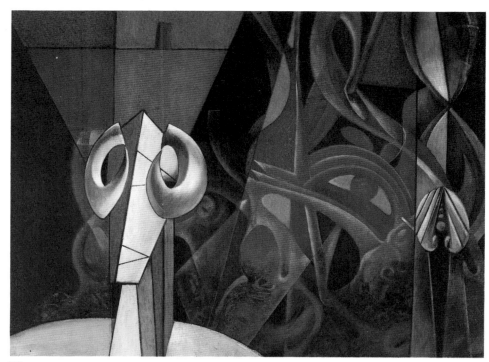

117

118

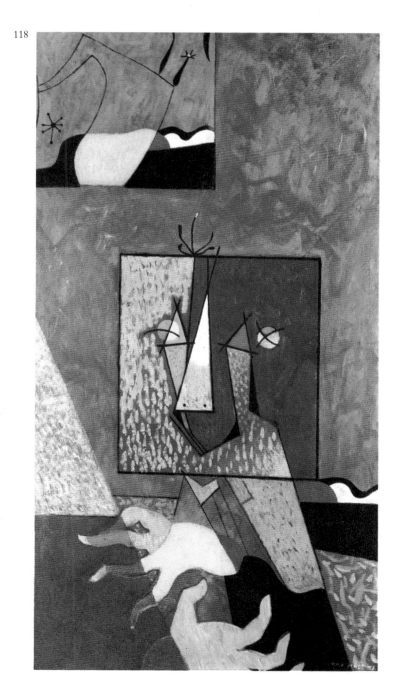

116. *Euclid.* 1945.
Oil on canvas, 64 × 59 cm.
De Ménil Family collection, Houston.

117. *Design in Nature.* 1947.
Oil on canvas, 50.8 × 66.7 cm.
De Ménil Family collection, Houston.

118. *Portrait of Joan Miró.* 1948.
Oil on canvas, 76 × 40.5 cm.
Knoedler Gallery, New York.

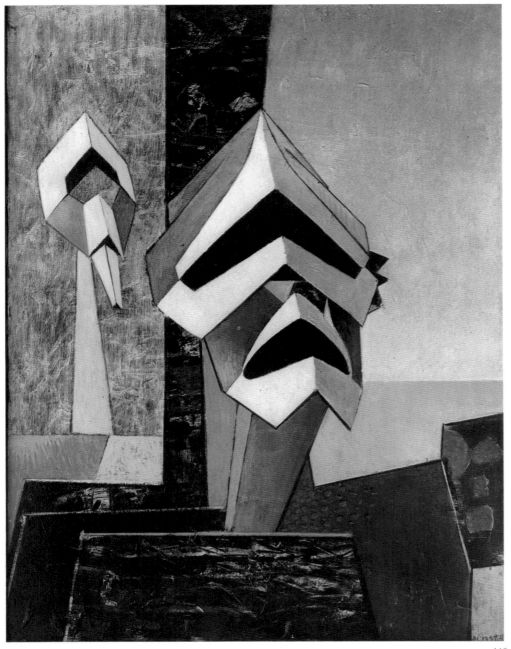

119

120

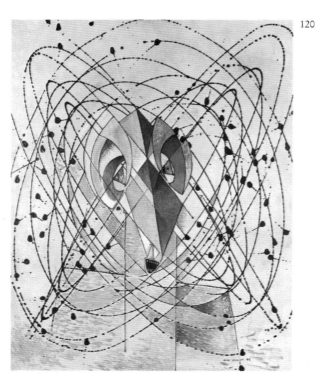

119. *The Birth of Comedy.* 1947.
Oil on canvas, 53 × 40 cm.
Günther and Carola Peill collection, Cologne.

120. *Young Man Intrigued by the Flight of a Non-Euclidean Fly.*
1942 and 1947.
Oil and varnish on canvas, 82 × 66 cm.
Dr Loeffler collection, Zürich.

121. *Feast of the Gods.* 1948.
Oil on canvas, 153 × 107 cm.
Museum des 20 Jahrhunderts, Vienna.

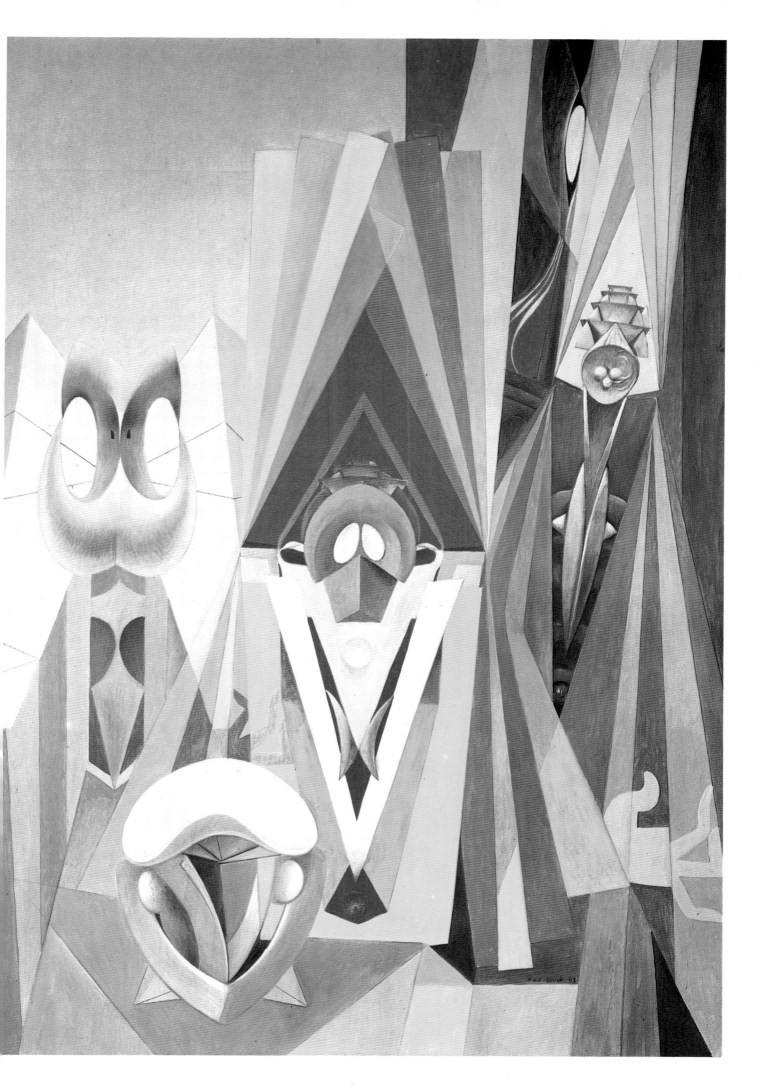

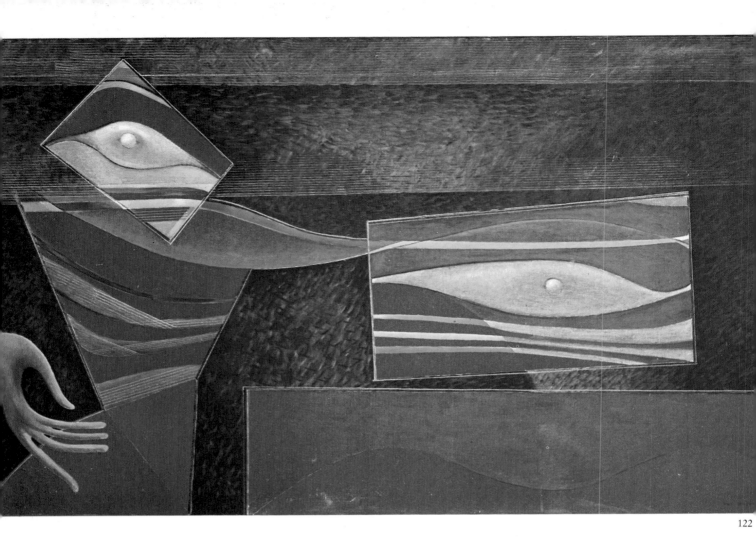

122

123

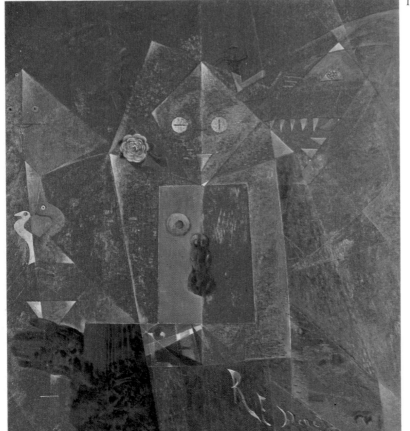

122. *The Two Foolish Virgins.* 1947.
Oil on canvas, 100 × 140 cm.
The artist's collection.

123. *The Blue Hour.* 1946-1947.
Oil, 100 × 91 cm.
Private collection.

124. *Chemical Nuptials.* 1947-1948.
Oil on canvas, 148 × 65 cm.
Private collection.

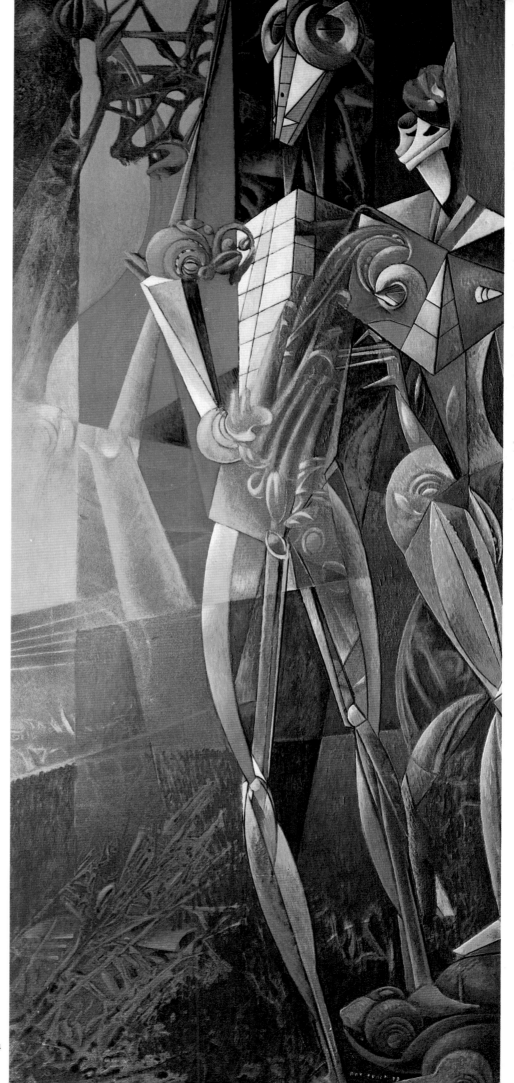

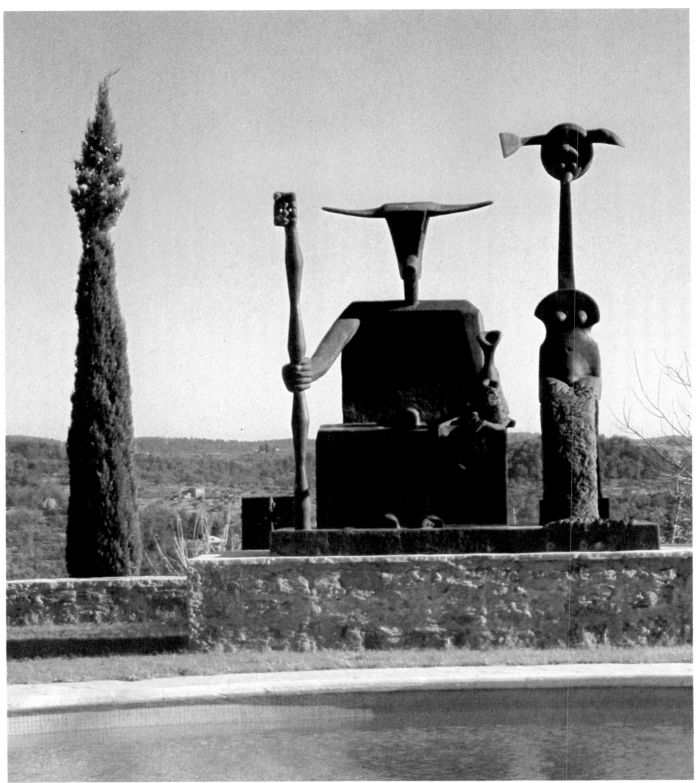

125

125. *Capricorn*. 1948.
 Cast in bronze in 1966.
 Max Ernst's garden at Seillans.

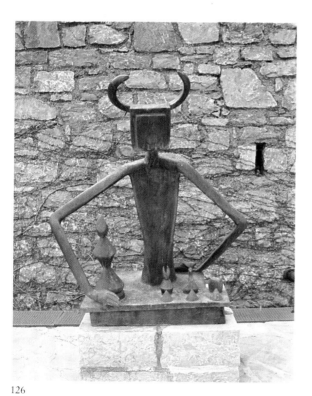

126

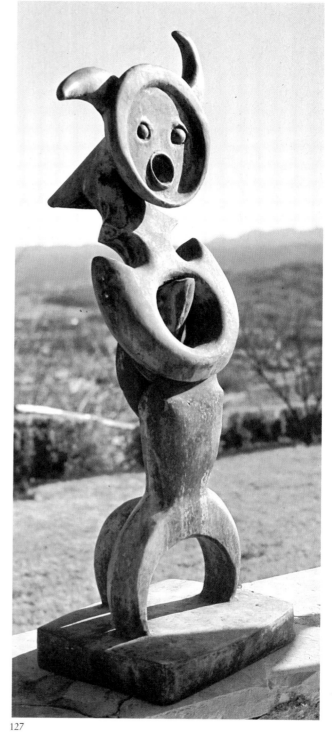

127

126. *The King Playing with the Queen.* 1944.
 Bronze, 100 cm.

127. *Moonmad.* 1944.
 Cast in bronze in 1956, 90 cm.

128. *Seen Through a Temperament (Microbes)*. 1949.
Oil on cardboard, 5 × 3.9 cm.
De Ménil Family collection, Houston.

129. *Colorado (Microbes)*. 1949.
Oil on cardboard, 3.2 × 6.4 cm.
De Ménil Family collection, Houston.

130. *Ten Thousand Lucid Redskins Prepare to Make the Rain
Laugh (Microbes)*. 1949.
Oil on cardboard, 3.2 × 5.8 cm.
De Ménil Family collection, Houston.

131. *Pacific Clouds*. 1950.
De Ménil Family collection, Houston.

132. *Cruel Greenery (Microbes)*. 1949.
Oil on cardboard, 3.5 × 5.4 cm.
De Ménil Family collection, Houston.

133. *The Polish Rider*. 1954.
Oil on canvas, 116 × 89 cm.
Private collection, Paris.

128

129

130

131

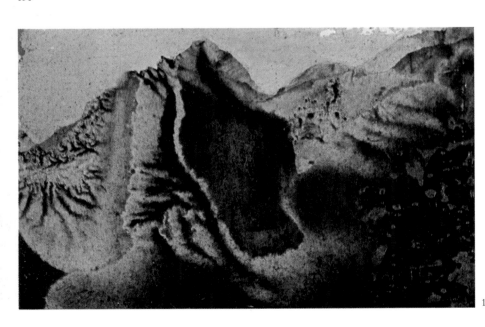

132

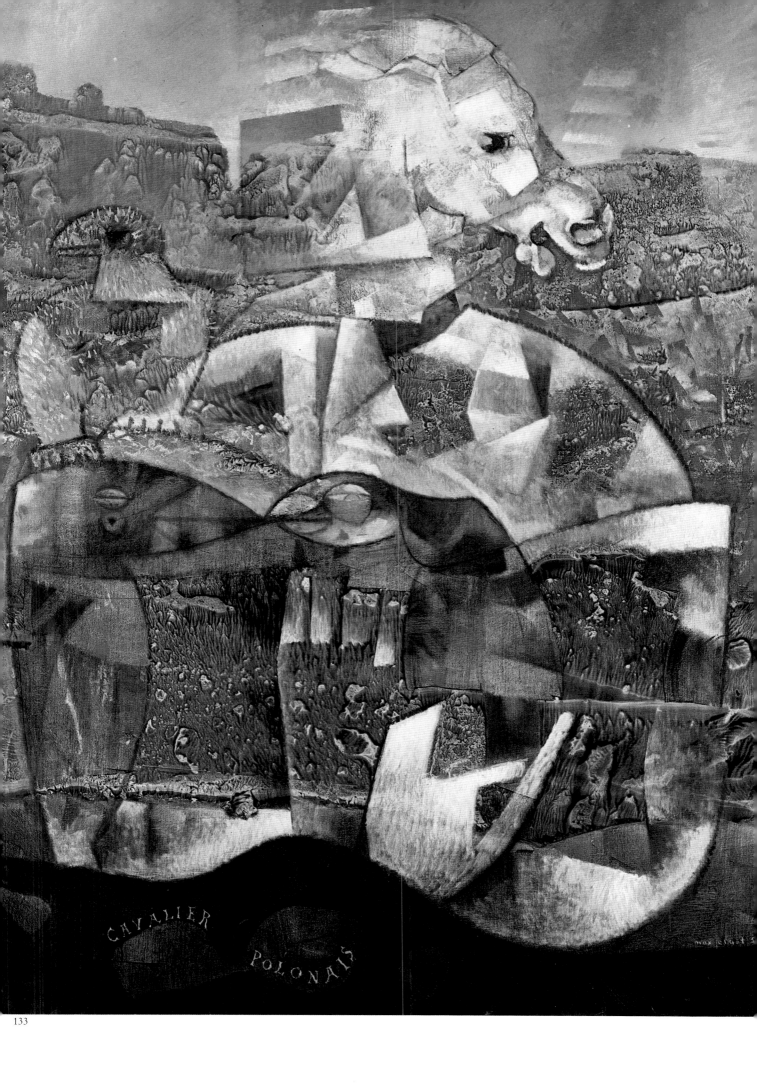

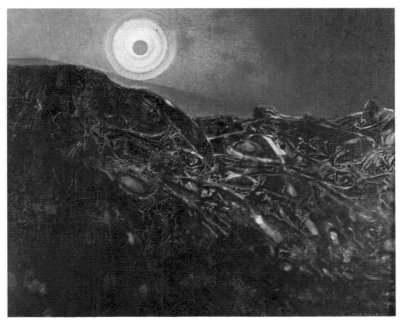

134

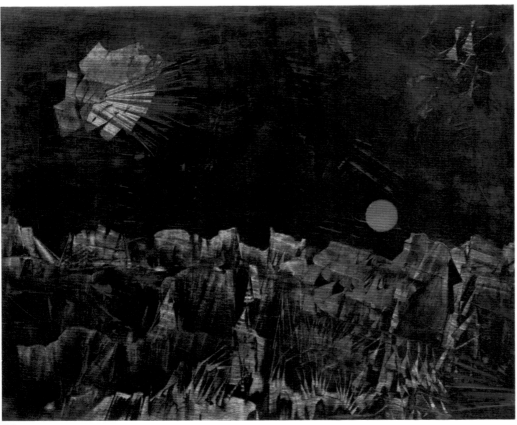

135

134. *The Twentieth Century.* 1955.
 Oil on canvas, 50.8 × 61 cm.
 De Ménil Family collection, Houston.

135. *Homage to Yves Tanguy.* 1955.
 Oil on canvas, 54 × 65 cm.
 Private collection, Italy.

136. *The Blind Dance by Night.* 1956,
 Oil on canvas, 196 × 114 cm.
 Jan Krugier Gallery, Geneva.

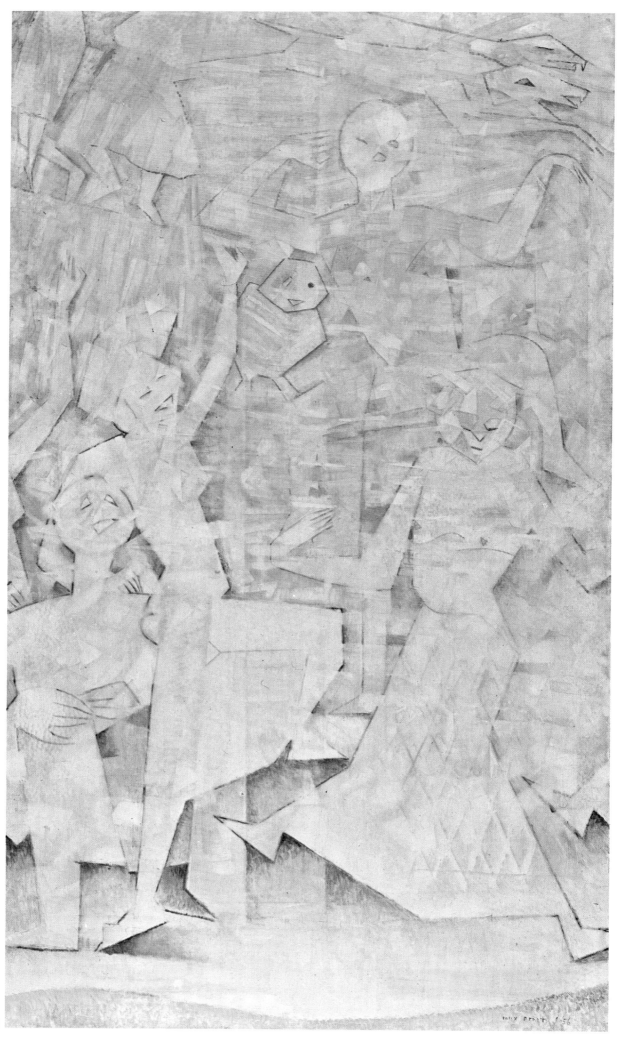

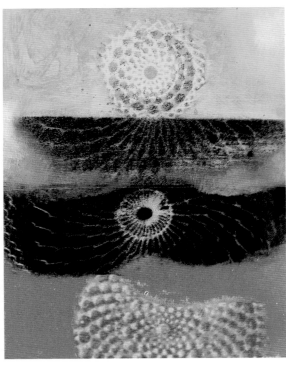

137

140

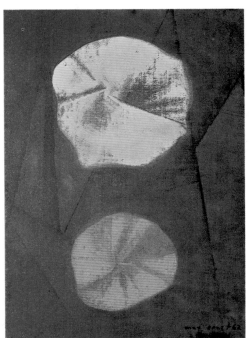

138

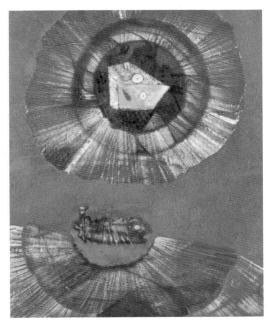

139

137. *Reflections.* 1962.
Oil on wood, 24 × 18.7 cm.
Ernst Beyeler Gallery, Basel.

138. *The Earth, with a Lie on its Lips.* 1960-1962.
Private collection.

139. *The Moon is a Mute Nightingale.* 1963.

140. *Here the Cardinals Are Dying.* 1962.
Oil on canvas, 89 × 117 cm.
The artist's collection.

141. *Explosion in a Cathedral.* 1960.
Oil on canvas, 129 × 195 cm.
Private collection.

142. *Untitled.* 1962.
Private collection.

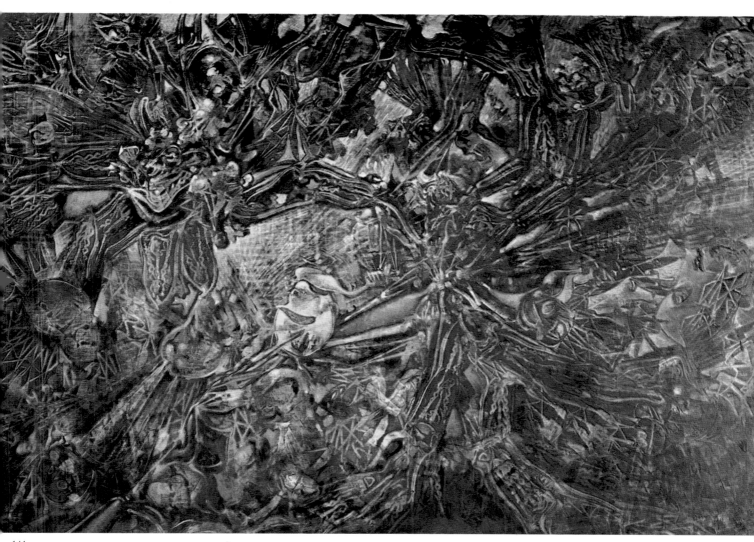

141

142

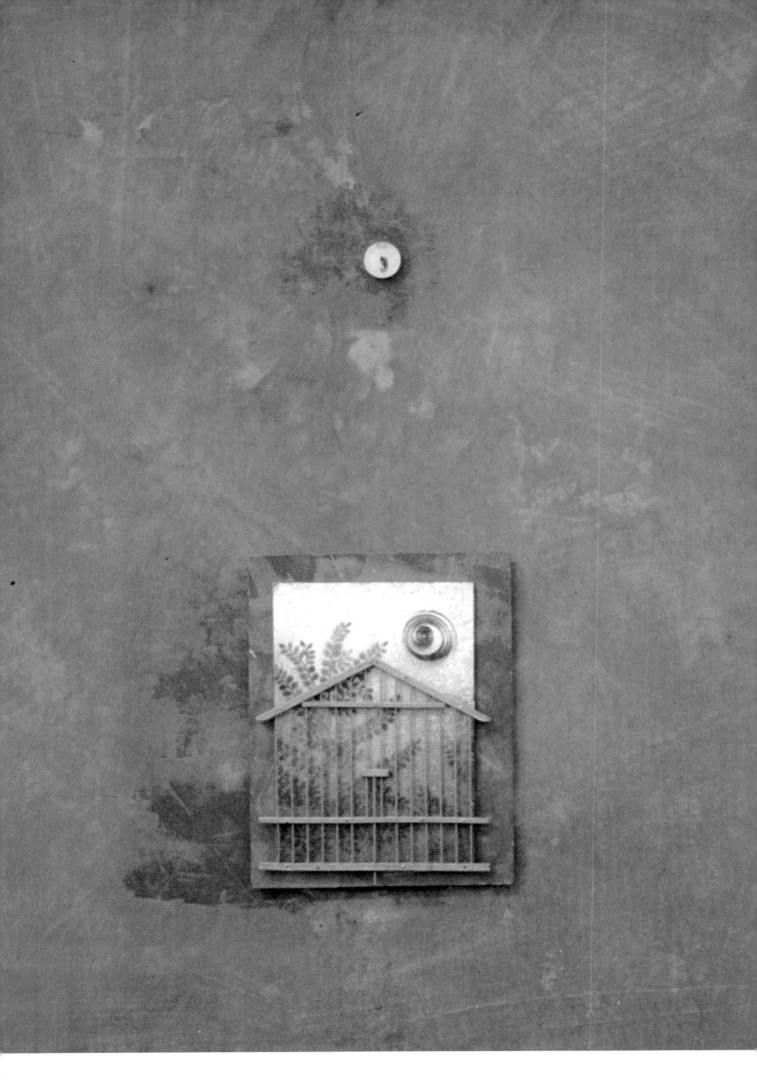

144

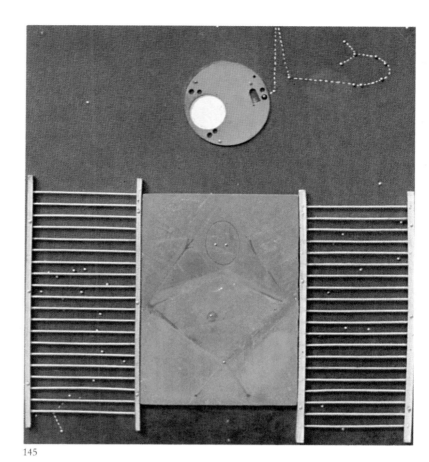

145

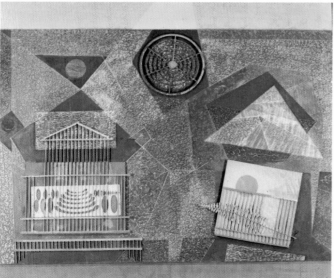

146

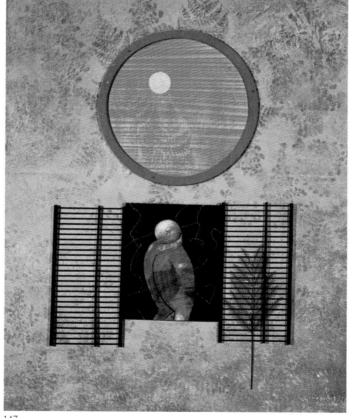

147

143. *Sanctuary*. 1965.
Oil and collage on wood, 116 × 82 cm.
The artist's collection.

144. *Woman, House, Sparrow*. 1965.
Oil and collage on plywood, 116 × 89 cm.
Private collection, Paris.

145. *The Great Ignoramus*. 1965.
Oil and collage on wood, 116 × 100 cm.
The artist's collection.

146. *The World of Confusions - Absolute Refusal to Live
as a Tachiste*. 1965.
Oil and collage on wood, 100 × 116 cm.
Private collection, Paris.

147. *First Thought*. 1965.
Oil and collage on wood, 100 × 80 cm.
The artist's collection.

148

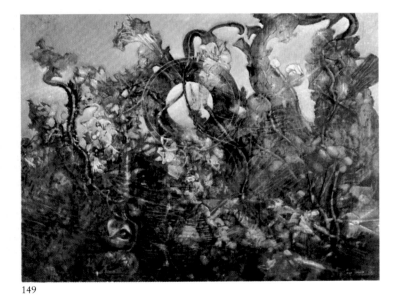

149

150

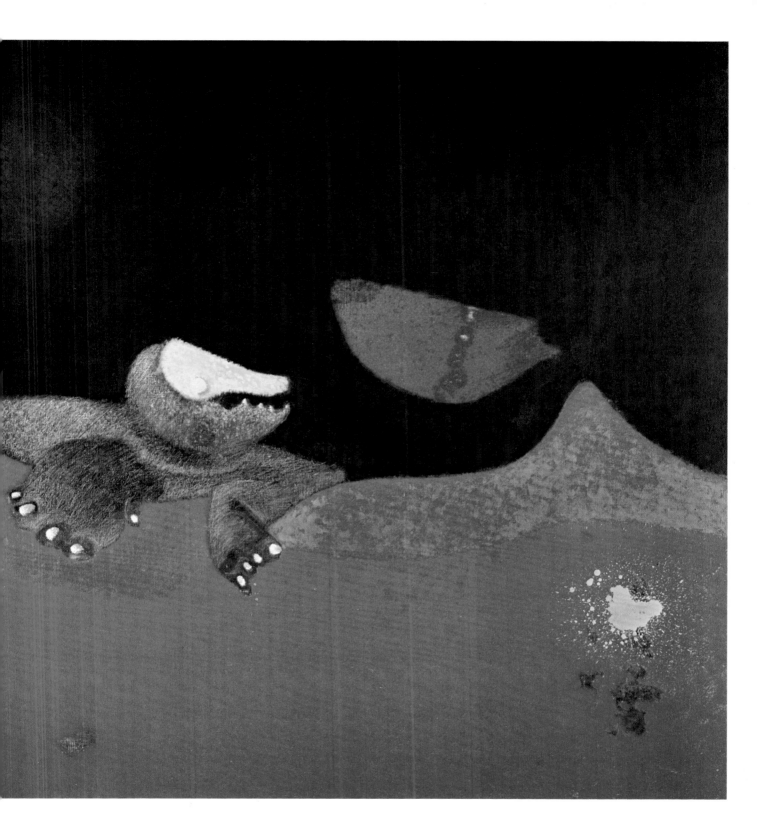

148. *The Last Forest (On Tuesday the Moon Puts on its Sunday Best).* First version.

149. *The Last Forest.* 1960-1969.
Oil on canvas, 114 × 146 cm.
Private collection.

150. *Sign for a School of Monsters.* 1968.
Oil on canvas, 88 × 115 cm.
The artist's collection.

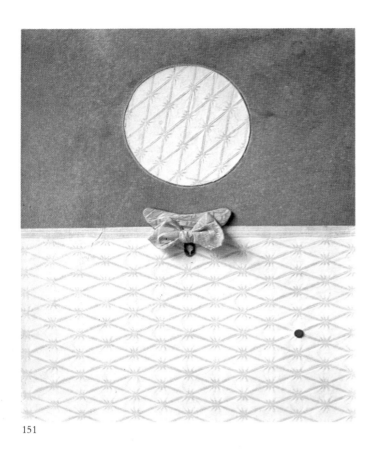

151

152

153

154

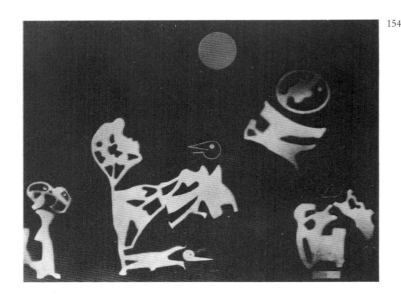

151. *The Impeccable One.* 1967.
Collage, 47 × 39 cm.

152. *Puce, Flea, Floh.* 1967.
Collage on wood, 51 × 43 cm.
Private collection.

153. *Tangled Lightning.* 1969.
Oil on canvas, 81 × 65 cm.
Private collection.

154. *Children Playing Astronauts.* 1969.
Oil on canvas, 89 × 116 cm.
Ernst Beyeler Gallery, Basel.

155. *Red Forest.* 1970.
The artist's collection.

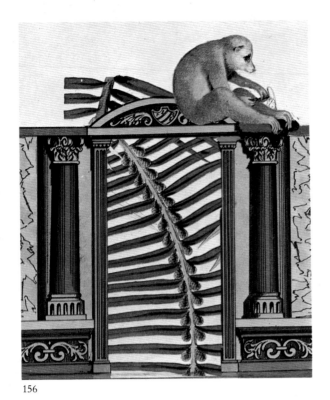

156

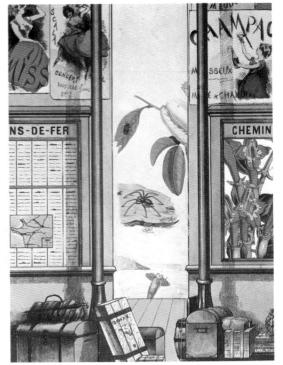

158

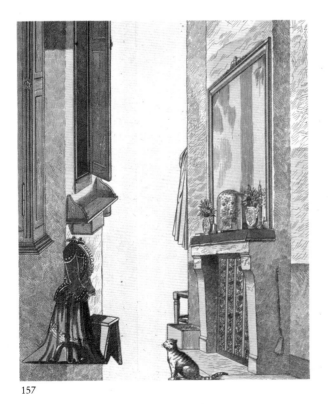

157

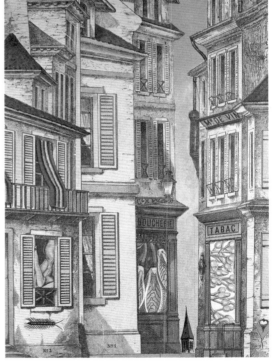

159

156. Frontispiece for 'Commonplaces.' 1971.
An album of 12 reproductions of collages accompanied
by 11 poems by Max Ernst (Éditions Iolas, Paris).

157. 'Commonplaces.' *Everyday.*

158. 'Commonplaces.' *Girls, Death and Devil.*

159. 'Commonplaces.' *Where to Unwind the Spool.*

160. *Several Animals, One Illiterate.* 1973.
Oil on canvas, 116 × 89 cm.
Private collection.

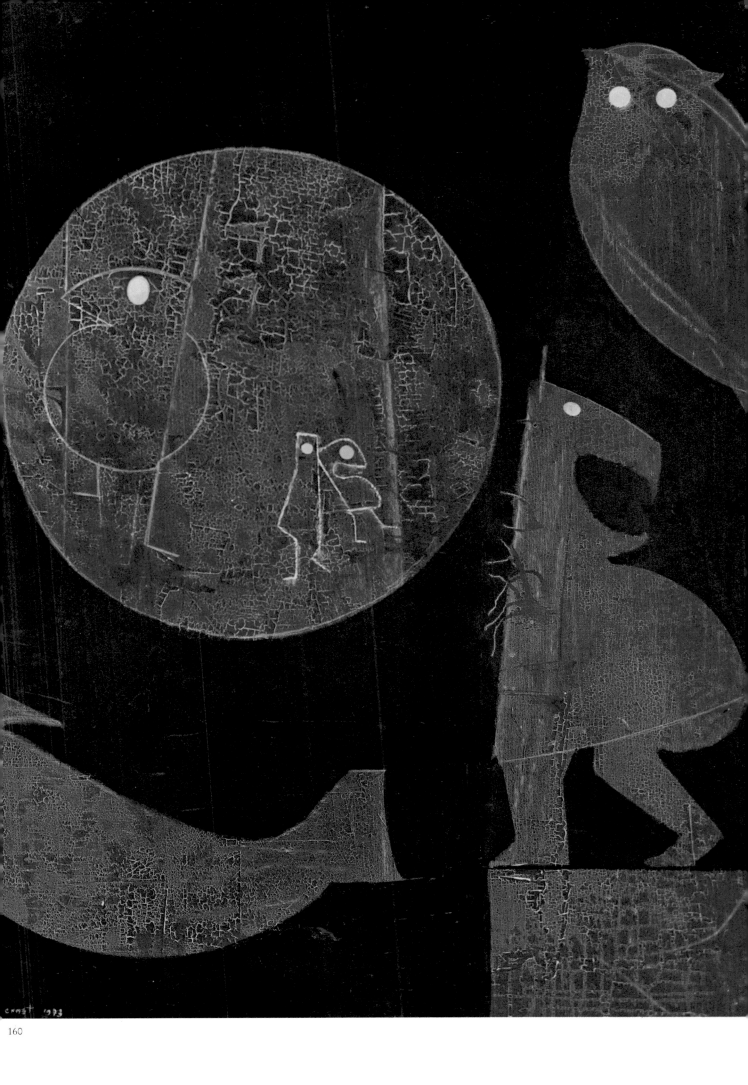

ernst 1973

160

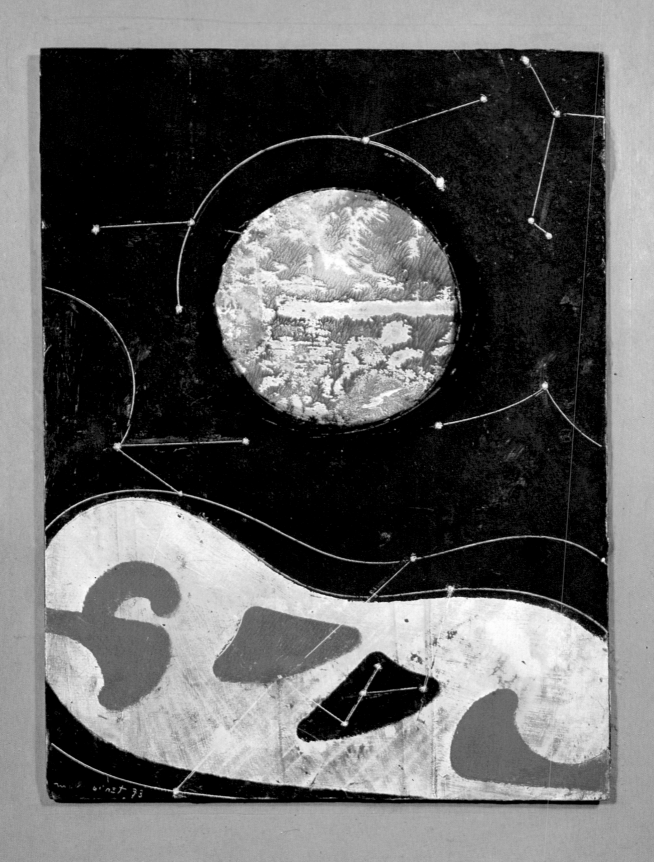

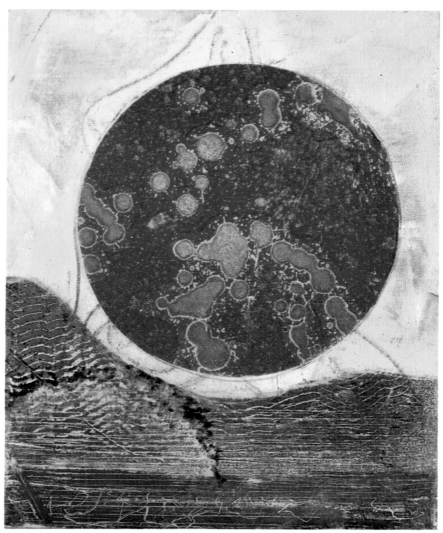

162

161. *Orbis Pictus.* 1973.
 Oil on two wooden panels, 46 × 36.7 cm.
 Private collection.

162. *Rien ne va plus.* 1973.
 Oil and collage on canvas, 27 × 22 cm.
 Private collection.

163. *Sunspot after the Style of Yester-Year.* 1972.
 Oil on two wooden panels, 60.5 × 52 cm.
 Private collection.

163

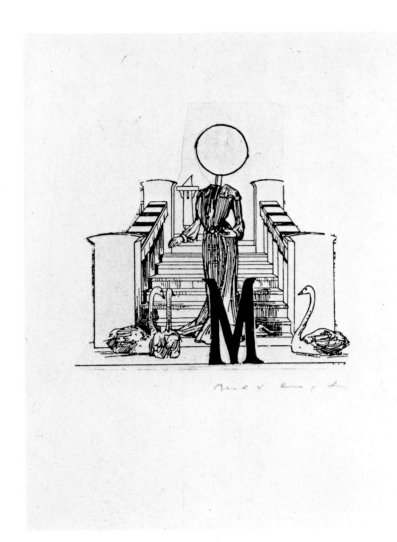

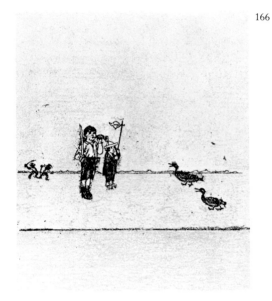
166

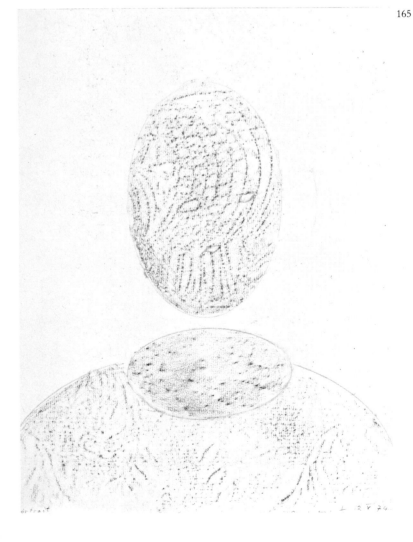
165

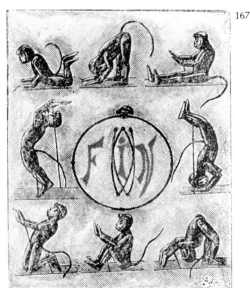
167

164. *Initial Letter M.* 1974.
Manuel de Muga collection, Barcelona.

165. *Portrait IX.* 1974.
Frottage, 31.7 × 22.9 cm.
Manuel de Muga collection, Barcelona.

166. Lithograph for *La ballade du soldat,* by Georges
Ribemont-Dessaignes, 1972.

167. Lithograph for *La ballade du soldat,* by Georges
Ribemont-Dessaignes, 1972.

168. *Configuration No. 16.* 1974.
Collage, *frottage* and pencil on paper, 28 × 16.5 cm.
Manuel de Muga collection, Barcelona.

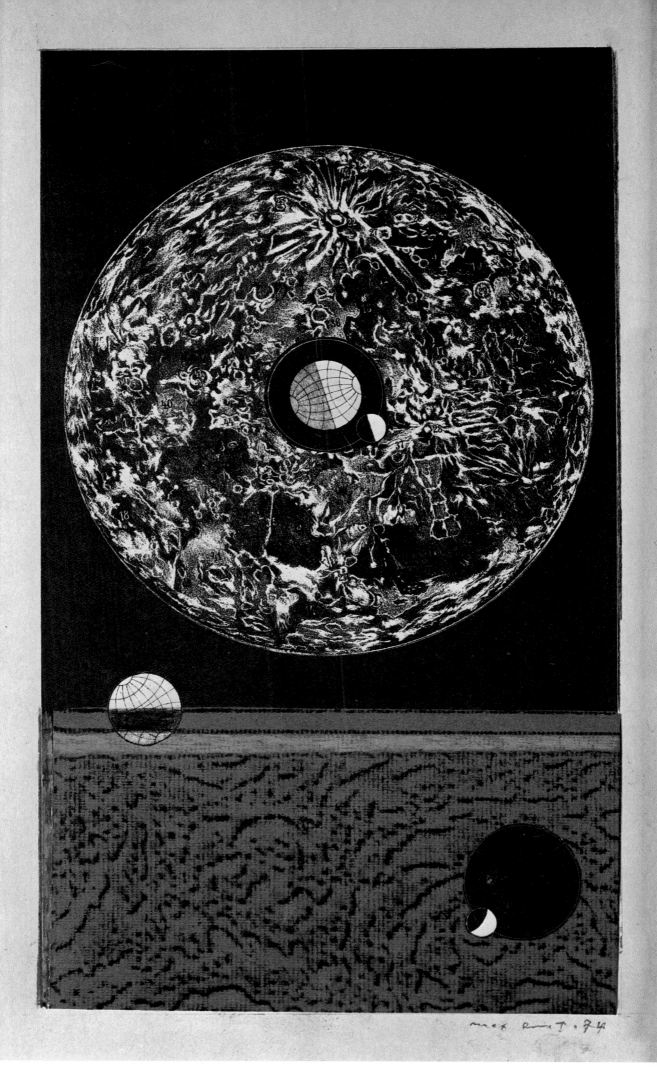

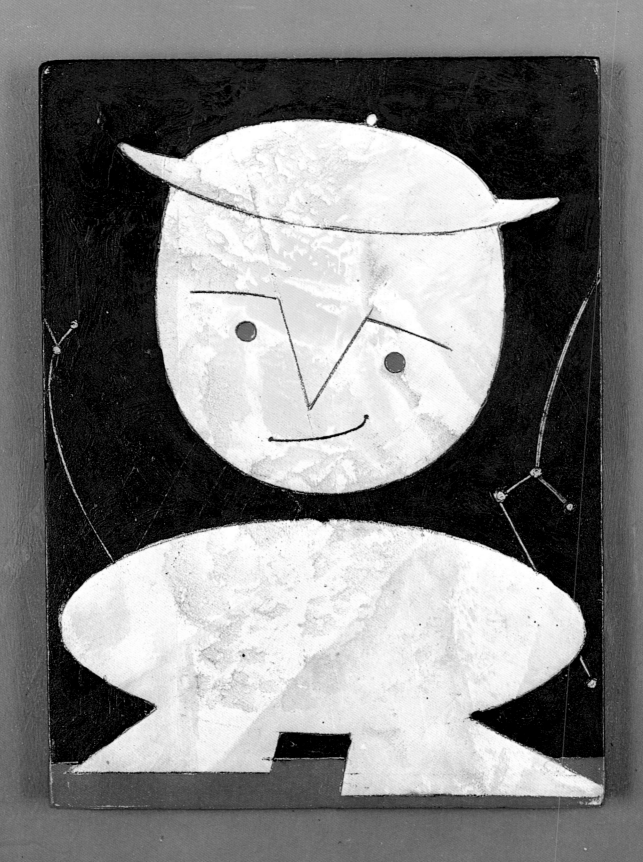

max ernst

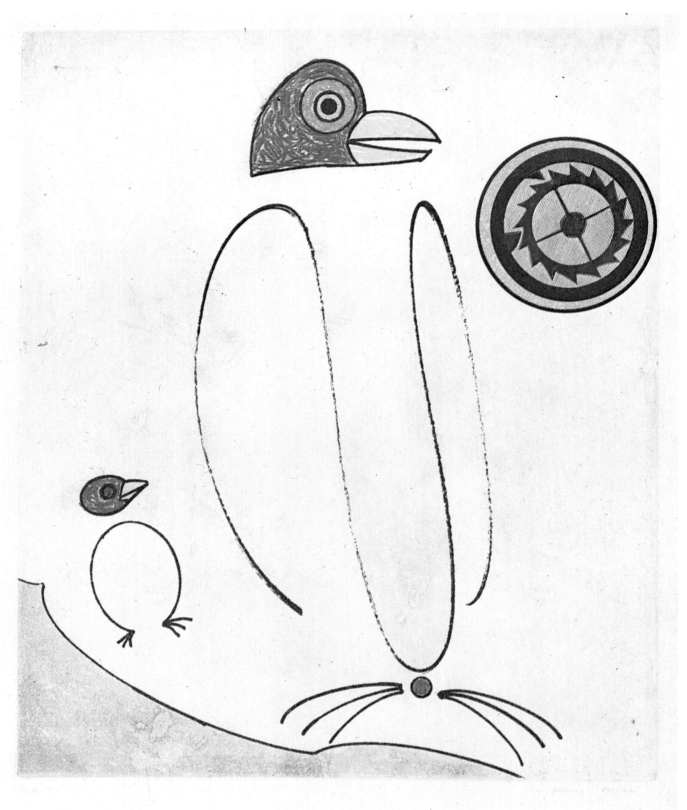

170

169. *Portrait of a Cardinal.* 1974.
 Oil on wood, 33 × 24 cm.
 Jan Krugier Gallery, Geneva.

170. Etching and aquatint with collage for *Oiseaux en péril.* 1975.
 Editions Georges Visat, Paris.

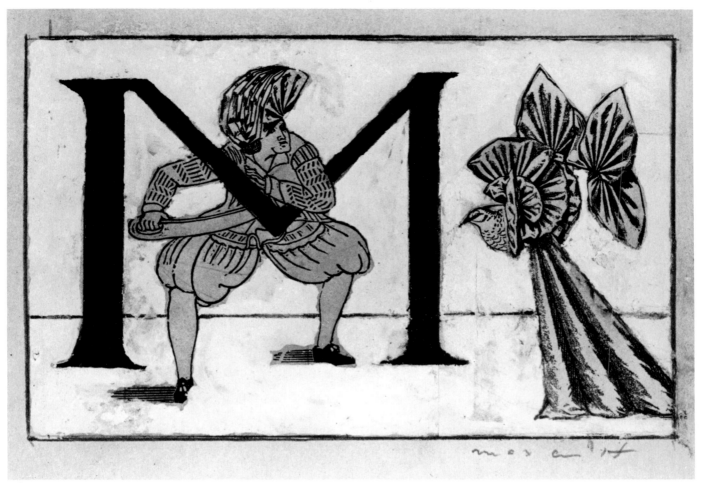

171

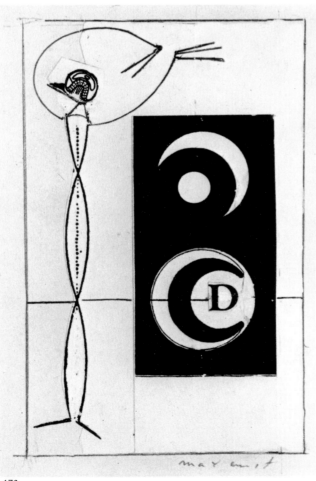

172

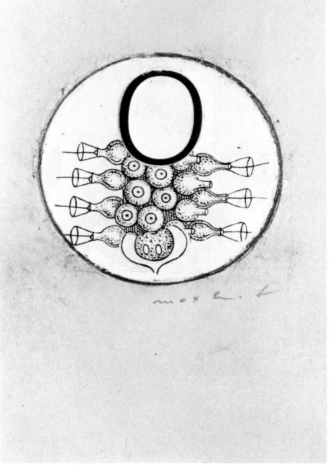

173

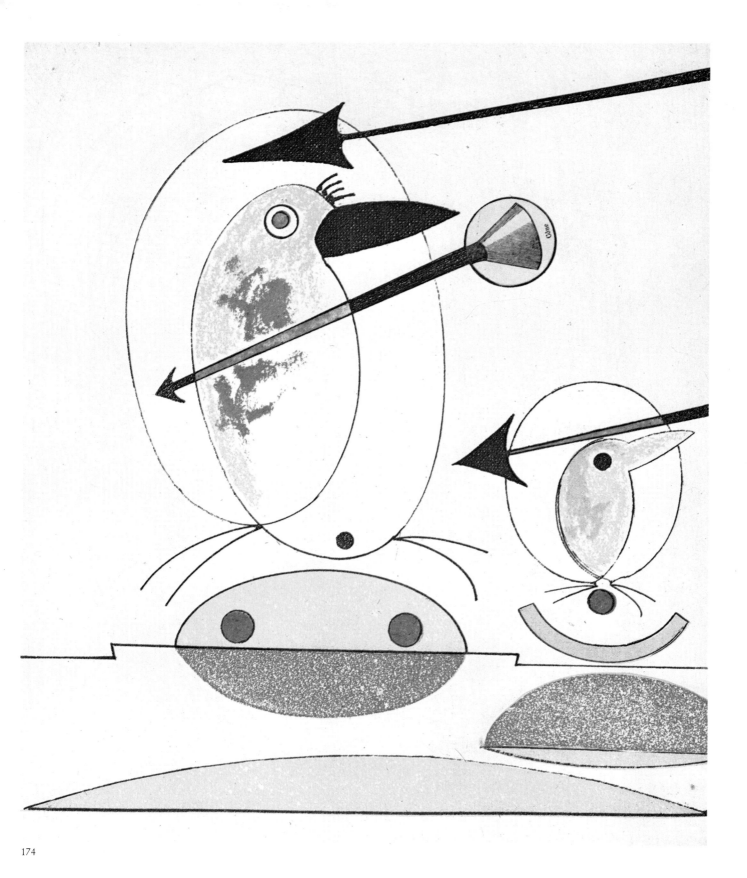

174

171. *M.* 1974.
 Collage-Lettrine, 10 × 10.6 cm.

172. *D.* 1974.
 Collage-Lettrine, 12.8 × 7.8 cm.

173. *O.* 1974.
 Collage-Lettrine, diameter 5.5 cm.

174. Etching and aquatint with collage for *Oiseaux en péril.* 1975.
 Editions Georges Visat, Paris.

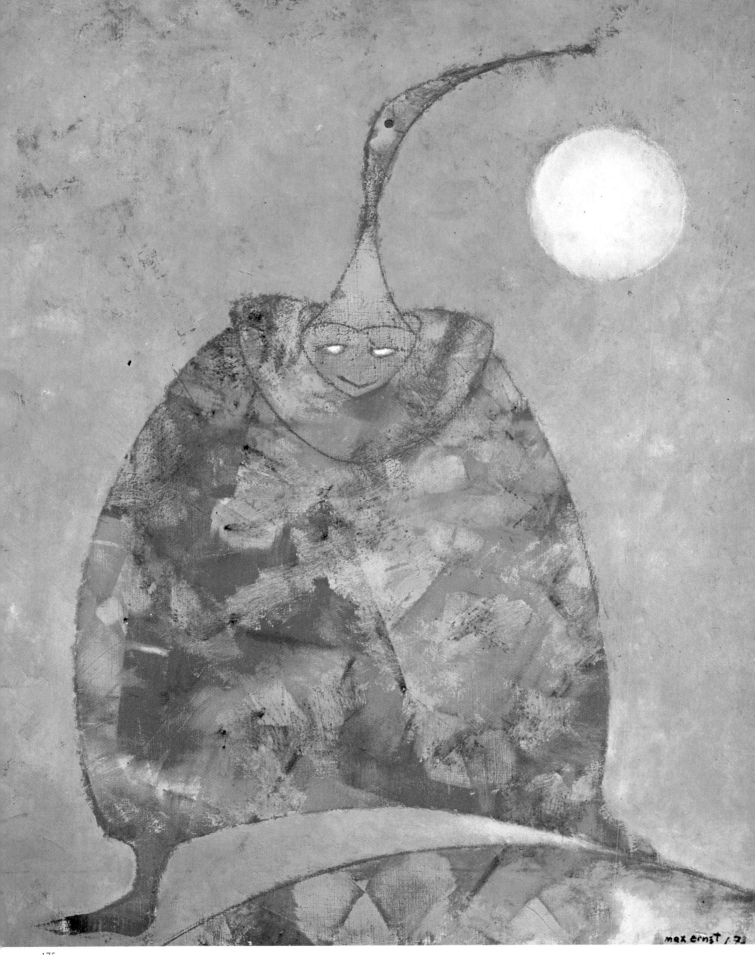

175

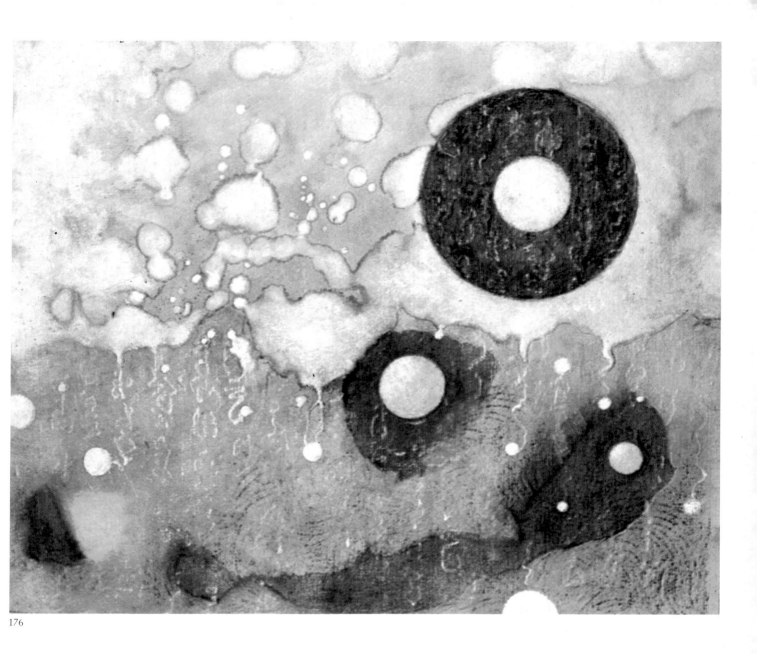

176

175. *My Friend Pierrot.* 1973-1974.
Oil on canvas, 116 × 89 cm.
Private collection.

176. *Configuration No. 6.* 1974.
Oil on canvas, 54 × 64.5 cm.
Jan Krugier Gallery, Geneva.

INDEX OF ILLUSTRATIONS

1. *Landscape with Sun.* 1909.
Oil on cardboard, 16.5 × 14 cm.
The artist's collection.

2. *Self-Portrait.* 1909.
Oil on cardboard, 18 × 12 cm.
Stadt Brühl collection.

3. *Landscape with Sun.* 1909.
Oil on cardboard, 18 × 13.5 cm.
The artist's collection.

4. *Street in Paris.* 1912.
Watercolour on paper, 34 × 44.2 cm.
Kunstmuseum collection, Bonn.

5. *The Railway Viaduct over the
Commesstrasse, Brühl.* 1912.
Oil on cardboard, 46 × 36 cm.
Stadt Brühl collection.

6. *Hat in Hand, Hat on Head.* c. 1913.
Oil on cardboard, 36.8 × 29.2 cm.
Roland Penrose collection, London.

7. *Immortality.* 1913-1914.
Oil on wood, 46 × 31 cm.
Minami Gallery, Tokyo.

8. *Crucifixion.* 1913.
Oil on paper, 51 × 43 cm.
Wallraf-Richartz Museum, Cologne.

9. *Town with Animals* or *Landscape.*
c. 1916.
Oil on canvas, 66.6 × 62.2 cm.
The Solomon R. Guggenheim Museum,
New York.

10. *Menace-Machines (Towers).* 1917.
Watercolour on paper, 14.6 × 22 cm.
Private collection, Paris.

11. *Landscape.* 1917.
Watercolour on paper, 15 × 22 cm.
M. H. Franke collection Murrhardt.

12. *Battle of Fish.* 1917.
Watercolour on paper, 21.7 × 14.5 cm.
M. H. Franke collection, Murrhardt.

13. *Battle of Fish.* 1917.
Watercolour on paper, 14 × 20.5 cm.
The artist's collection.

14. *Aquis Submersus.* 1919.
Oil on canvas, 54 × 43.8 cm.
Roland Penrose collection, London.

15. *The great orthochromatic wheel that
makes love to measure.* 1919-1920.
Watercolour and pencil on printed
sheets, 35.5 × 22.5 cm.
Michel Leiris collection, Paris.

16. *Two Ambiguous Figures.* 1919-1920.
Collage with gouache and pencil on
paper, 24.2 × 16.7 cm.
Arp collection, Clamart (missing since
1966).

17. *Fruit of a Long Experience.* 1919.
Relief, painted wood and metal,
45.7 × 38 cm.
Private collection, Geneva.

18. *The Cormorants.* 1920.
Photocollage and Indian ink on paper
(Fatagaga), 15.5 × 13 cm.
Simone Breton-Collinet collection, Paris.

19. *Farewell my Fair Land of MARIE
LAURENCIN.* 1919.
Printer's proof and ink on paper,
39.3 × 27.5 cm.
The Museum of Modern Art, New York.

20. *The Swan is Very Peaceful.* 1920.
Photocollage, 8.3 × 12 cm.
Mrs Alfred H. Barr Jr collection,
New York.

21. *Hydrometric demonstration of how
to kill by temperature.* 1920.
Collage and gouache on paper,
24 × 17 cm.
J. Tronche collection, Paris.

22. *Switzerland, Birth-Place of Dada* or
Physiomythological Flood-Picture. 1920.
Fatagaga done in co-operation with Hans
Arp. Collage on paper, 11.2 × 10 cm.
Kestner-Museum, Hanover, Fritz-Behrens
collection.

23. *Augustine Thomas and Otto Flake*
or *Otto Flake synthesizes the art of the
corset with the taste for fine stuffs and
metaphysical meat, while Arp prefers the
meat of the flowers of evil.* 1920.
Photocollage by Louise Ernst-Strauss on
paper, 23 × 13.5 cm.
Kestner-Museum, Hanover, Fritz-Behrens
collection.

24. *Mine Hostess on the Lahn.*
Collage with gouache and watercolour
on paper, 25 × 31.5 cm.
Private collection, Stuttgart; on
permanent loan to Staatsgalerie, Stuttgart.

25. *Above the clouds goes the midnight.
Above the midnight glides the invisible
bird of the day, a little higher than the
bird the ether blows, and the walls and
the roofs float.* 1920.
Photocollage and pencil, 18.3 × 13 cm.
Mrs. Alfred H. Barr Jr collection,
New York.

26. *The Chinese Nightingale.* 1920.
Photocollage and Indian ink on paper,
12.2 × 8.8 cm.
Guy Genon-Catalot collection, Paris.

27. *The Punching-Ball* or *The
Immortality of Buonarotti* or *Max Ernst
and Caesar Buonarotti.* 1920.
(Fatagaga). Collage, photograph and
gouache on paper, 17.6 × 11.5 cm.
Arnold H. Crane collection, Chicago.

28. *The Little Tear Gland that Says
Tick-Tock.* 1920.
Gouache on wallpaper, 35.6 × 25.4 cm.
The Museum of Modern Art, New York.

29. *Dada-Degas.* c. 1920.
Collage and gouache on paper,
48 × 31 cm.
Louis Aragon collection, Paris.

30. *Manifesto: Dada Stirs Everything Up*.
Paris, 12 January 1921.
B. Gheerbrant collection, Paris.

31. *Max Ernst's Bedroom; it's worth spending a night here*. c. 1920.
Collage with gouache and pencil on paper, 16.3 × 22 cm.
Werner Schindler collection, Zürich.

32. *The Word* or *Bird-Woman*. 1921.
Illustration for *Répétitions* by Paul Éluard, 1922.
Collage and gouache on paper, 18.5 × 10.6 cm.
E. W. Kornfeld collection, Berne.

33. *Glacial Landscapes, Icicles & Minerals of the Female Body*. 1920.
Collage, gouache and watercolour on paper, 25.3 × 24.4 cm.
Moderna Museet, Stockholm.

34. *The Horse, He's Sick*. 1920.
Collage, pencil and ink on paper, 14.5 × 21.6 cm.
The Museum of Modern Art, New York, Abby Aldrich Rockefeller Fund.

35. *Approaching Puberty* or *The Pleiads*. 1921.
Photocollage, gouache and oil on paper, 24.5 × 16.5 cm.
René Rasmussen collection, Paris.

36. *The Elephant of the Celebes*. 1921.
Oil on canvas, 125 × 107 cm.
The Tate Gallery, London.

37. *Oedipus Rex*. 1922.
Oil on canvas, 93 × 102 cm.
Private collection, Paris.

38. *Young Chimera*. 1921.
Collage, gouache and Indian ink on paper, 26 × 9 cm.
Simone Breton-Collinet collection, Paris.

39. *The Fall of an Angel*. 1922.
Collage and oil on paper, 44 × 34 cm.
Ernst O. E. Fischer collection, Krefeld.

40 *The Couple* or *The Couple in Lace*. 1923.
Oil on canvas, 101.5 × 142 cm.
Boymans van Beuningen Museum, Rotterdam.

41. *Pietà* or *Revolution by Night*. 1923.
Oil on canvas, 116 × 89 cm.
Private collection, Turin.

42. *Untitled*. 1923.
Door of Paul Éluard's house at Eaubonne.
Oil on wood, 205 × 80 cm.
Galerie des Quatre Mouvements, Paris.

43. *Reality Must Not Be Seen as I Am*. 1923.
Fresco in Paul Éluard's house at Eaubonne later transferred to canvas, 175 × 80 cm.
Galerie André-François Petit, Paris.

44. *Teetering Woman* or *An Equivocal Woman*. 1923.
Oil on canvas, 130.5 × 97.5 cm.
Kunstsammlung Nordrhein-Westfalen, Düsseldorf.

45. *Saint Cecilia (The Invisible Piano)*. 1923.
Oil on canvas, 101 × 82 cm.
Staatsgalerie, Stuttgart.

46. *At the First Clear Word*. 1923.
Fresco in Paul Éluard's house at Eaubonne, later transferred to canvas, 232 × 167 cm.
Kunstsammlung Nordrhein-Westfalen, Düsseldorf.

47. *Who Is the Tall Sick Person...?*
c. 1923-1924.
Oil on canvas, 65.4 × 50 cm.
Siegfried Adler collection, Montagnola.

48. *Long Live Love* or *Charming Countryside*. 1923.
Oil on canvas, 131.5 × 98 cm.
Morton D. May collection, St. Louis.

49. *Ubu Imperator*. 1923.
Oil on canvas, 100 × 81 cm.
Hélène Anavi collection, Paulhiac.

50. *Dadaville*. c. 1924.
Painted plaster of Paris and cork on canvas 66 × 56 cm.
Roland Penrose collection, London.

51. *Two Girls Are Threatened by a Nightingale*. 1924.
Oil on wood, with wooden elements added, 69.8 × 57 × 11.4 cm.
The Museum of Modern Art, New York.

52. *Sunday Guests*. 1924.
Oil on canvas, 55 × 65 cm.
Henri Parisot collection, Sceaux.

53. *Portrait M.* or *The Letter*. 1924.
Oil on canvas, 83 × 62 cm.
Ernst Beyeler Gallery, Basel.

54. *The Couple* or *The Embrace*. 1924.
Oil on canvas, 73 × 54 cm.
Mrs. Jean Krebs collection, Brussels.

55. *The Beautiful Season*. 1925.
Oil on canvas, 58 × 108 cm.
Bonomi collection.

56. *Portrait of Gala*. 1924.
Oil on canvas, 81.5 × 65.4 cm.
Muriel Kallis Newman collection, Chicago.

57. *Untitled*. 1925.
Frottage, pencil on paper.

58. *The Forest*. 1925.
Oil on canvas, 115.5 × 73.5 cm.
Jan Krugier Gallery, Geneva.

59. *Leaf Customs*. 1925.
Frottage, pencil on paper, 42.7 × 26 cm.
Ernst Fischer collection, Krefeld.

60. *Two Sisters*. 1926.
Oil on canvas and frottage in black lead-pencil, 100.3 × 73 cm.
De Ménil Family collection, Houston.

61. *The Great Forest*. 1927.
Oil on canvas, 114.5 × 146.5 cm.
Kunstmuseum, Basel.

62. *Dark Forest and Bird*. 1926.
Oil on canvas, 65.5 × 81.5 cm.
Private collection, U.S.A.

63. *Forest, Bird, Sun*. 1926.
Private collection.

64. *Forest*. 1927-1928.
Oil on canvas, 27 × 22 cm.
Jan Krugier Gallery, Geneva.

65. *The Blessed Virgin Chastising the Child Jesus Before Three Witnesses: A.B.* [André Breton], *P.E.* [Paul Éluard] *and the artist*. 1926.
Oil on canvas, 196 × 130 cm.
Mrs Jean Krebs collection, Brussels.

66. *Earth-Beam, the Sea and the Sun*. 1927.
J. B. Urvater collection, Paris.

67. *Monument to the Birds*. 1927.
Oil on canvas, 162 × 130 cm.
Private collection.

68. *Child, Horse, Flower and Snake*. 1927.
Oil on canvas, 71.5 × 82 cm.
HAG Kunststiftung collection, Zürich.

69. *They Have Slept too Long in the Forest*. 1927.
Oil on canvas, 46 × 55 cm.
Evelyne Lévy collection, Paris.

70. *The Family*. 1927.
Oil on canvas, 81.5 × 66 cm.
Ernst Beyeler Gallery, Basel.

71. *The Horde*. 1927.
Oil on canvas, 114 × 146 cm.
Stedelijk Museum, Amsterdam.

72. *The Kiss*. 1927.
Oil on canvas, 60 × 128 cm.
Peggy Guggenheim collection, Venice.

73. *The Forest*. c. 1928.
Oil on canvas, 27 × 34.8 cm.
Sprengel collection, Hanover.

74. *Forest*. 1929.

75. *Shell Flowers*. 1929.
Oil on canvas, 129 × 129 cm.
Musée National d'Art Moderne de Paris.

76. *Fishbone Forest*. 1929.
Oil on canvas, 54 × 65 cm.
Ernst Beyeler Gallery, Basel.

77. *Inside Sight: the Egg*. 1929.
Oil on canvas, 98.5 × 79.4 cm.
De Ménil Family collection, Houston.

78. *Inside Sight*. 1929.
Oil on canvas, 120 × 100 cm. Private collection, Paris.

79. *Loplop Introduces a Young Girl*. 1930.
Oil and different materials on wood, 175 × 89 cm.
The artist's collection.

80. *Human Form*. 1931.
Oil on gesso on wood, 183 × 100 cm.
Moderna Museet, Stockholm.

81. *La Foresta Imbalsamata*. 1933.
Oil on canvas, 162 × 253 cm.
De Ménil Family collection, Houston.

82. *Forest and Sun*. 1932.
Oil on paper, 22.5 × 31 cm.
Dr and Mrs Henry Roland collection.

83. Collage by Max Ernst for *A Week of Kindness*. Editions Jeanne Bucher, 1934.

84.' Illustration by Jules Mary for *Les damnés de Paris*.
Paris, J. Rouff éditeur, 1883.
Starting-point for the collage
in Max Ernst's illustration (Fig. 83).

85 & 86. *A Week of Kindness* or *The Seven Capital Elements*. 1934.
Collage-novel.

87 & 88. *A Week of Kindness* or *The Seven Capital Elements*. 1934.
Collage-novel.

89. Collage by Max Ernst for *A Week of Kindness*. 1934.

90. Illustration by Jules Mary for *Les damnés de Paris*, 1883.
Starting-point for the collage in Max Ernst's illustration (Fig. 89).

91. *Barbarians Marching Westward*. 1935.
Oil on paper, 24 × 32 cm.
Private collection, New York.

92. *The Entire City*. 1935-1936.
Oil on canvas, 60 × 80 cm.
Kunsthaus, Zürich.

93. *Hunger Feasts*. 1935.
Oil on canvas, 19 × 24.2 cm.
De Ménil Family collection, Houston.

94. *The Angel of Hearth and Home*. 1937.
Oil on canvas, 112.5 × 144 cm.
Private collection.

95. *The Nymph Echo*. 1936.
Oil on canvas, 46 × 55 cm.
The Museum of Modern Art, New York.

96. *Lust for Life*. 1936.
Oil on canvas, 72 × 91 cm.
Roland Penrose collection, London.

97. *The Angel of Hearth and Home*. 1937.
Oil on canvas, 54 × 74 cm.
Jan Krugier Gallery, Geneva.

98. *Human Figure (Les Milles)*. 1939.
Frottage and gouache, 60 × 47 cm.
Brooks Jackson collection.

99. *Epiphany*. 1940.
Oil on canvas, 52 × 64 cm.
Richard Feigen Gallery, New York.

100. *The Robing of the Bride*. 1939.
Painting on wood, 130 × 96 cm.
Peggy Guggenheim collection, Venice.

101. *The Antipope*. 1941-1942.
Oil on canvas, 160 × 127 cm.
Peggy Guggenheim collection, Venice.

102. *Desert*. 1940.
Oil on canvas, 15 × 20.5 cm.
Jan Krugier Gallery, Geneva.

103. *Marlene (Woman and Child)*.
December 1940-January 1941.
Oil on canvas, 23.8 × 19.5 cm.
De Ménil Family collection, Houston.

104. *The Witch*. 1941.
Oil on canvas.
Alfred Barr collection, New York.

105. *Europe After the Rain II*.
1940-1942.
Oil on canvas, 54 × 145.5 cm.
Wadsworth Athenaeum, Hartford, The Ella Gallup Sumner and Mary Carlin Sumner Collection.

106. *The Nation of the Birds*. 1941.
Pastel on paper, 46 × 33 cm.
Private collection.

107. *Day and Night*. 1941-1942.
Oil on canvas, 112 × 146 cm.
Private collection.

108. *Torpid Town*. 1943.
Oil on canvas, 120 × 74 cm.
Private collection.

109. *The Bewildered Planet*. 1942.
Oil on canvas, 119 × 140 cm.
The Tel-Aviv Museum.

110. *Arizona Landscape*. 1943.
Oil on wood, 36.5 × 34.5 cm.
Jan Krugier Gallery, Geneva.

111. *The Luncheon on the Grass*. 1944.
Oil on canvas, 68 × 150 cm.
Private collection.

112. *The Cocktail Drinker*. 1945.
Oil on canvas, 116 × 72.5 cm.
Kunstsammlung Nordrhein-Westfalen, Düsseldorf.

113. *Painting for Young People*. 1943.
Oil on canvas, 61 × 76 cm.
Jan Krugier Gallery, Geneva.

114. *The Temptation of Saint Anthony*. 1945.
Oil on canvas, 108 × 128 cm.
Wilhelm-Lehmbruck-Museum der Stadt Duisburg.

115. *The Temptation of Saint Anthony*. (Detail). 1945.

116. *Euclid*. 1945.
Oil on canvas, 64 × 59 cm.
De Ménil Family collection, Houston.

117. *Design in Nature*. 1947.
Oil on canvas, 50.8 × 66.7 cm.
De Ménil Family collection, Houston.

118. *Portrait of Joan Miró*. 1948.
Oil on canvas, 76 × 30.5 cm.
Knoedler Gallery, New York.

119. *The Birth of Comedy*. 1947.
Oil on canvas, 53 × 40 cm.
Günther and Carola Peill collection, Cologne.

120. *Young Man Intrigued by the Flight of a Non-Euclidean Fly*. 1942 and 1947.
Oil and varnish on canvas, 82 × 66 cm.
Dr Loeffler collection, Zürich.

121. *Feast of the Gods*. 1948.
Oil on canvas, 153 × 107 cm.
Museum des 20 Jahrhunderts, Vienna.

122. *The Two Foolish Virgins*. 1947.
Oil on canvas, 100 × 140 cm.
The artist's collection.

123. *The Blue Hour*. 1946-1947.
Oil, 100 × 91 cm.
Private collection.

124. *Chemical Nuptials*. 1947-1948.
Oil on canvas, 148 × 65 cm.
Private collection.

125. *Capricorn*. 1948
Cast in bronze in 1966.
Max Ernst's garden at Seillans.

126. *The King Playing with the Queen*. 1944.
Bronze, 100 cm.

127. *Moonmad*. 1944.
Cast in bronze in 1956, 90 cm.

128. *Seen Through a Temperament (Microbes)*. 1949.
Oil on cardboard, 5 × 3.9 cm.
De Ménil Family collection, Houston.

129. *Colorado (Microbes)*. 1949.
Oil on cardboard, 3.2 × 6.4 cm.
De Ménil Family collection, Houston.

130. *Ten Thousand Lucid Redskins Prepare to Make the Rain Laugh (Microbes)*. 1949.
Oil on cardboard, 3.2 × 5.8 cm.
De Ménil Family collection, Houston.

131. *Pacific Clouds*. 1950.
De Ménil Family collection, Houston.

132. *Cruel Greenery (Microbes)*. 1949.
Oil on cardboard, 3.5 × 5.4 cm.
De Ménil Family collection, Houston.

133. *The Polish Rider*. 1954.
Oil on canvas, 116 × 89 cm.
Private collection, Paris.

134. *The Twentieth Century*. 1955.
Oil on canvas, 50.8 × 61 cm.
De Ménil Family collection, Houston.

135. *Homage to Yves Tanguy*. 1955.
Oil on canvas, 54 × 65 cm.
Private collection, Italy.

136. *The Blind Dance by Night*. 1956.
Oil on canvas, 196 × 114 cm.
Jan Krugier Gallery, Geneva.

137. *Reflections*. 1962.
Oil on wood, 24 × 18.7 cm.
Ernst Beyeler Gallery, Basel.

138. *The Earth, with a Lie on its Lips*. 1960-1962.
Private collection.